OILS

by J. M. Parramon

Published by
H.P. Books
P.O. Box 5367
Tucson, AZ 85703
602/888-2150

ISBN: 0-89586-073-2
Library of Congress Catalog
Number: 80-82379

This text © 1980 Fisher Publishing Co., Inc.
Printed in U.S.A.

Publisher: Bill Fisher
Editorial Director: Jonathan Latimer
Editor: Randy Summerlin
Editorial Advisor: Donna Hoffman
Art Director: Don Burton
Design & Assembly: Patrick O'Dell
Typography: Cindy Coatsworth, Joanne Nociti

Published in Great Britain by
Fountain Press
Argus Books Ltd.

Third Edition in English, 1978

Original title in Spanish
"Asi se pinta al oleo"
© 1968 Jose M.a Parramon Vilasalo

Deposito Legal B- 29. 804-78
Numero de Registro Editorial 785

CONTENTS

Oil Paints
Brushes
Surfaces for Painting
Other Equipment

The 14th and 15th centuries witnessed a great change in all aspects of life in Western Europe. We now call this period of exploration the Renaissance, and no field underwent greater changes than the arts. The Gothic tradition of painting flat, symbolic portraits of religious or royal figures was replaced by styles of painting that allowed room for individuality. Perspective was discovered and artists strove for a more realistic rendering of their subjects. Compare *The Virgin with Child and Angels* on page 6 with *Arnolfini and His Bride* on page 7 and you will quickly see the differences.

Two great schools of painting developed during the Renaissance, the Northern or *Flemish* school and the Southern or *Italian* school. Both shared one major trait: They brought the medium of oil painting into new prominence. The Flemish school included such masters as Jan van Eyck, Bosch, Breugel, Rubens, Vandyke and Rembrandt. The Italian school included Leonardo da Vinci, Michaelangelo, Raphael, Titian and Botticelli.

There is an interesting legend about the discovery of oil techniques. Before the Renaissance, every artist painted his boards and altarpieces with egg tempera colors. But the colors were difficult to shade and lost brightness when they dried. It was found that if a coat of oil was applied over the egg tempera, the colors revived and recovered the strength and brilliance of newly painted works. The book *Diversarum Artium Schedula*, written around 1200 by the monk Teofilo, recommended that a coat of olive oil be applied over tempera. However, it was very difficult to dry olive oil and the painting had to be placed in the sun for several hours or even days, which involved risking that the painting would deteriorate, the colors darken and the whites lose their strength.

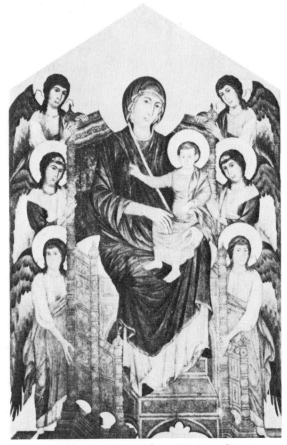

The Virgin with Child and Angels (1272) by Cimbau (The Louvre, Paris). The Florentine painter Cimbau is one of the artists who made great efforts to humanize Gothic art by giving it more expression. Nevertheless, his style reflects the classic features of Gothic painting: figures on a flat, unrealistic background, with stylized expressions and positions, forming a conventional composition.

According to legend, Jan van Eyck placed a painting in the sun to dry as Teofilo recommended. When he came to take it in a few hours later, he was furious to find that the picture had cracked.

From then on van Eyck searched for an oil which would dry without cracking. He found that linseed oil mixed with nut oil dried comparatively easily, and eventually he discovered that mixing a small amount of the linseed oil with "white varnish," which we now call turpentine, produced a solution which dried easily in the shade. But that did not satisfy him.

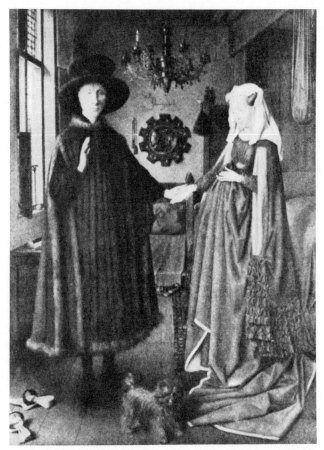

Arnolfini and His Bride (1434) by Jan van Eyck (National Gallery, London). One of the most famous paintings by this great Flemish artist represents the new style of the Renaissance. The careful painting of each background detail shows how concerned the artist was to reproduce the pure reality of the objects and furnishings which form part of men's lives. The cold accuracy of the forms appears to be veiled in vibrant light, creating a realistic atmosphere.

Van Eyck then mixed the raw colors used for tempera painting into this solution, instead of painting the solution over them. He found that these mixed colors could be applied in transparent washes or opaque coats which would dry perfectly without having to place the painting in the sun.

These legendary discoveries may not have taken place in just that way, but the great creative explosion in oil painting begins about that time. Oil painting has been prominent for so long, there are those who say it is the *only* way to paint.

Materials For Oil Painting

OIL PAINTS

Generally speaking, when we paint in oils today, we use the same ingredients as those employed by Jan van Eyck five hundred years ago. Oil paints are composed of two elements: *colors* or *pigments,* and *adhesives.*

Pigments are solid and usually made in powdered form. They were originally divided into two categories: *organic*, which are obtained from vegetables and animals, and *inorganic*, obtained from minerals. One modern development has been the creation of a third type, *synthetic* colors manufactured from chemicals.

These colors or pigments are not used exclusively in oil painting. They are common to all techniques that use colors: watercolors, temperas, wax, pastels or oils. When combined with adhesives such as water, gum arabic, honey or glycerine, they provide watercolors. When combined with water, gum substances and oils, they provide pastel colors. When combined with adhesives such as fatty oils and chemicals, resins, balsams and waxes, they give us oil paints.

THE COLORS

In the following discussion, the term *colors* refers to the powdered pigments. These can be divided into the whites, yellows, reds, blues, greens, browns and blacks.

All colors have the property of being opaque or transparent. Opaque colors absorb light instead of reflecting it. Once they are placed on a surface, you cannot see through them. Transparent colors transmit light, and you can see the surface or coats of paint beneath them.

WHITES

In oil painting, as in other opaque techniques such as tempera or pastels, white is one of the most frequently used colors, so tubes of white oils are generally larger than those of other colors.

The most commonly used are *white lead* or *flake white, zinc white* and *titanium white.*

White Lead or Flake White—This has an astonishing degree of opacity and strength as a covering substance, and it is very quick drying. These qualities can be very useful when you need paste-like coats. It is also suitable for backgrounds or first coats. It is highly poisonous if swallowed or inhaled; never handle it in dry powder form. It is not used for watercolors.

Zinc White—This has a colder tone than white lead, is less compact and slightly better than semi-opaque. It also dries slowly. Slower drying can be an advantage when you are painting a picture which requires several sessions and you need to work on an undercoat which is not completely dry. Also, it is not poisonous.

Titanium White—In comparison with the other two whites, this is a modern pigment with strong coloring power. It possesses normal opacity and dries in average time. It is very popular with most artists.

YELLOWS

The most common yellows are: *Naples yellow, chrome yellow, cadmium yellow, yellow ochre* and *raw sienna.*

Naples Yellow—This is obtained from lead antimonate and is one of the oldest colors. It is a heavy semi-opaque yellow and dries quickly. Like all lead pigments, it is poisonous. It can be mixed with any other color without trouble provided that it is pure and of good quality. Rubens used it, especially for flesh-tints.

Chrome Yellow—This is another pigment obtained from lead and is thus poisonous. There are several shades ranging from a very bright lemonish color to a very dark, almost orange shade. It is opaque and dries quickly but is easily affected by light, tending to darken over the years, especially the lighter shades.

Cadmium Yellow—A good strong, brilliant color, which dries rather slowly. It can be mixed with every color except the copper-based pigments. It is a bright, very opaque, permanent color obtained from cadmium sulfide. It is an excellent color and very popular for oil painting.

Yellow Ochre—This is an earth pigment colored by iron. It has great coloring and covering power, and can be mixed safely and easily with any other color, provided that it is pure. It is also produced artificially without losing any of these qualities.

Raw Sienna—This is another earth pigment containing iron and manganese, made from the soil of Siena, Italy. It is a beautiful and brilliant color but is liable to darken when it is diluted with a lot of oil. So, when painting in oils, it is not advisable to use natural sienna for extensive undersurfaces or for large areas in which it is used as an ingredient. However, it is an excellent pigment when not mixed with oil, for instance in tempera.

REDS

Among the most commonly used are: *burnt sienna, vermilion, cadmium red* and *alizarin crimson.*

Burnt Sienna —This has the same characteristics as raw sienna but is darker and has a reddish tinge. It can be used in every painting technique, including oil painting, without the danger of darkening later. It was widely used by the old masters, primarily the Venetians. Some writers claim that it was the color employed by Rubens for painting the brilliant reds and reflected highlights of his flesh-tints.

Vermilion —This luminous red pigment is obtained from minerals or produced artificially. It covers well but does not dry easily. It is used in every technique but is liable to darken if exposed to the sun. It is inadvisable to mix it with copper-based pigments or white lead.

Cadmium Red —This is preferable to vermilion because it does not darken when exposed to the sun. A brilliant, powerful color, it can be mixed with any other color except copper-based pigments such as opaque green.

Alizarin Crimson —Made from alizarin, an organic coal tar derivative, this is an extremely powerful color providing a rich range of reddish, purple and carmine tones. It is very liquid, dries slowly, is permanent and is suitable for every technique except frescoes.

BLUES AND GREENS

The most popular blues and greens are: *terre-verte, permanent green, viridian, cobalt blue, ultramarine blue* and *Prussian blue.*

Terre-Verte —Obtained from ochre, this pigment produces a brownish, khaki green. It is a very old color which can be used for every technique. It dries comparatively quickly and covers well.

Permanent Green—A bright luminous green produced from a mixture of viridian and cadmium yellow. A safe pigment without any drawbacks.

Viridian—Also known as *emeraude green*, this should not be confused with *emerald green* (*Veronese green*) which has many drawbacks. Made from oxide of chrome, viridian is considered the best of the greens because of its tonal range and richness, and its permanency and safety.

Cobalt Blue—This metallic non-poisonous pigment can safely be used for every technique. It is a bright, clear, nearly transparent color, somewhat similar to ultramarine blue but not as deep and intense. It covers well and dries quickly, which can be inconvenient when it is applied over coats which are not very dry and produces cracks. As an oil color it can acquire a slight greenish tint in time, due to the amount of oil it requires. Both a light and dark shade are available.

Ultramarine Blue—Like cobalt blue, this blue has been used since ancient times. It is obtained from lapis lazuli, a semi-precious stone, and was formerly the most expensive color. Now it is produced artificially. It is completely permanent, has average opacity and requires normal drying time. It is suitable for every technique except frescoes in the open where the color decomposes. It is available in dark and light shades and in some cases has a more reddish tinge than cobalt blue.

Prussian Blue or Paris Blue—This transparent pigment has a strong coloring power and dries well. It is a deep, intense cyan or greenish blue. Its greatest drawback is that it is affected by light, which can destroy its color. But the color is regained when placed in darkness for some time. It is inadvisable to mix it with vermilion or zinc white.

BROWNS

The most widely used browns are: *raw umber* and *burnt umber*, and *Vandyke brown.*

Raw Umber and Burnt Umber—Both pigments are natural earths and a by-product of calcination. They are both very dark, but raw umber has a slight greenish tint while the burnt shade is slightly reddish. They can be used for every technique, but darkening is

unavoidable over time. They dry very quickly and so it is not advisable to apply them in thick coats if you want to prevent cracking.

Vandyke Brown—This has a dark tone similar to the umbers but with a rather grayish tinge. It cannot be recommended for painting undercoats in oils because it cracks easily. It can be used for final coats, retouching and in mixtures for small areas, but is safer in watercolors than in oils. It becomes a cold dirty gray in the open air.

BLACKS

The best known are *lamp black* and *ivory black*.

Lamp Black—Made from pure carbon, this black has a rather cold shade. It is permanent and can be used for every technique.

Ivory Black—Made from impure carbon, this is a slightly warm shade. It may provide a deeper black than lamp black, and it is suitable for every type of painting.

THE ADHESIVES

Linseed Oil—This is a fatty oil. It is obtained from flax seeds and produced by *cold pressing* them. This means that they are crushed without heat, which provides the most suitable oil for painting. Linseed oil has a bright yellow color and dries well in three or four days, but it must be pure and clean to prevent the colors from darkening. It is

used for dissolving and cementing the colors. The amounts vary according to the structure and fineness of the pigments. It is also employed as a solvent during the actual painting, and in some formulas for preparing fabrics, papers or boards for oil painting.

Other fatty oils used in oil painting include nut oil and poppy oil, both of which dry more slowly.

Essence of Turpentine—This is a pine distillation. It is a solvent that is white and clear and gives off a strong aromatic smell. When in contact with air, it dries rapidly by evaporation. Essence of turpentine is not a cementing substance in the strict sense of the word. But it is an unbeatable liquid for diluting pigments and dissolving balsams, resins and waxes. It is also the best thinning substance for oil colors while painting. We discuss this on page 28.

Mastic and Damar Resin—These resins are used in oil painting as varnishes and to prevent wrinkles, films and subsequent contraction and damage when the painting dries *from within.* When heated in a double boiler, they blend with essence of turpentine. Damar is superior in hardness, wears longer and can be mixed with linseed oil to make a permanent medium. Mastic reacts with oil and is safe only when used in a simple picture varnish which contains no drying oils.

Beeswax—This pure wax is used in oil painting as a medium for colors from the tube. It prevents the oil and the pigments from separating, so the colors do not dry or solidify in the tube. It also causes better color consistency. A mixture with as little as 2% of wax heated and blended with essence of turpentine is enough.

MIXING YOUR OWN

Many books on painting techniques and materials suggest that you follow the example of the old masters and make your own paints. They even suggest you avoid buying ready-made paints because you cannot be absolutely sure of their purity. It is also sometimes claimed that within a few years your paintings will become yellow and stale, the colors will darken or the picture will crack if you use commercially made paints.

An artist grinding pigments in the l7th century, after Ryckaert. Engraving by Maurice Bousset.

However, you will discover that few modern artists make their own oil paints. Almost without exception, they buy them ready-made from art supply shops.

If you buy a good brand of oil color, you will have little trouble. Why waste your time making paints? Better to not bother about anything except painting.

Large shops have color charts supplied by manufacturers. These charts usually cover a wide range of up to 75 to 90 colors, which is much more than most of us need. To show what I mean, here is list of yellows from a color chart: lemon yellow, lemon cadmium yellow, light cadmium yellow, medium cadmium yellow, dark cadmium yellow, zinc yellow, cobalt yellow, Naples yellow, reddish Naples yellow, light chrome yellow, medium chrome yellow and dark chrome yellow.

Don't let this array confuse you. Remember that few, if any, professional painters use more than ten or twelve colors, plus white and black. These ten or twelve colors must include the three primaries: yellow, red and blue or, more precisely, medium cadmium yellow, alizarin crimson and cobalt blue (or Prussian blue). The colors listed on the following page are those most commonly used by professional artists.

COLORS COMMONLY USED BY PROFESSIONAL ARTISTS

Titanium white	Medium cadmium red
Lemon cadmium yellow	Alizarin crimson
Medium cadmium yellow	Viridian
Yellow ochre	Cobalt blue
Raw sienna	Ultramarine blue
Burnt sienna	Prussian blue
Burnt umber	Ivory black

Twelve colors in all, plus white and black. You will see that white is one of the essential colors while black can be omitted. In fact, it is the least necessary because it can be made by mixing other colors, such as Prussian blue, alizarin crimson and burnt umber. You can also purchase starter sets of paints which include all the colors necessary to begin work.

Brands—Oil paints are available in two grades: student and artist. Student oil colors are not as refined, but for the beginner they are fine to use and less expensive. The following brands are all high quality: Talens, Bellini, Shiva, Permanent Pigments, Bocour, Winsor Newton, and Grumbacher. Experiment with each. Your taste will determine which brand you prefer for any particular color or painting quality. Even professional artists commonly use one brand for most colors, with perhaps one or two of a different make.

Size—Oil colors are sold in tin tubes with a screw top. Each brand sells two or three different size tubes. The most common size tubes available are a 1 x 4 inch No. 14 holding 37cc, and 1 x 6 inch No. 40 holding 122cc. There are also available smaller 1/2 x 3 inch No. 3 tubes, which hold 8cc of paint. These are usually sold in sets and are considered too small for serious painters. When buying colors, remember to always ask for a larger tube of white because this is the color used the most.

CARING FOR YOUR PAINTS

Oil colors are expensive. If a tube is not properly sealed after each use, the paint can be ruined. It will thicken or even become dry and hard in the tube and this is impossible to remedy. So, don't forget to put the caps back on your tubes when you are finished painting.

THE MOST COMMON OIL COLORS

These are the oil colors most commonly used. Titanium white would also be included on your actual palette and sometimes ivory black.

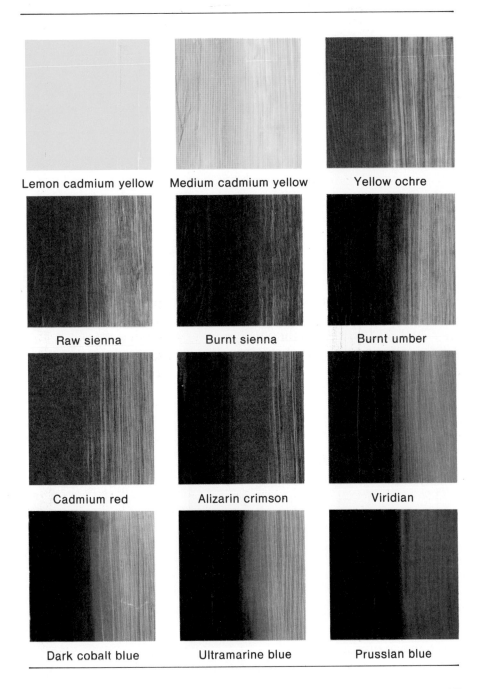

Lemon cadmium yellow	Medium cadmium yellow	Yellow ochre
Raw sienna	Burnt sienna	Burnt umber
Cadmium red	Alizarin crimson	Viridian
Dark cobalt blue	Ultramarine blue	Prussian blue

Sometimes the cap of a tube becomes stuck to the screw top, either because it has been left unused for several days between painting sessions or because that particular tube is seldom used. If this happens, do not try to unscrew the cap by force. You may break the tube. Simply light a match and hold the cap over the flame. When the cap is hot, it can be unscrewed easily, but use a rag so you don't burn your fingers. Another method is to run the cap of the tube under hot water and use a nutcracker or pliers to unscrew the cap.

BRUSHES FOR OIL PAINTING

At an art supply store you are likely to find several very large boxes divided into compartments which hold numbered brushes. Oil brushes are made of white hog bristles or red sable fur, and each number designates a different size. Camel-hair brushes are usually too soft for oil painting.

Buy good quality brushes with long bristles or hair. They are more flexible, keep their shape and last longer. Nothing is more frustrating than to have to pick bristles or hairs out of your oil painting. This is a common experience when you buy cheap brushes.

The brushes most commonly used for oil painting are called *hog bristles*, but for special areas, *sable brushes* are also used. Hog bristles

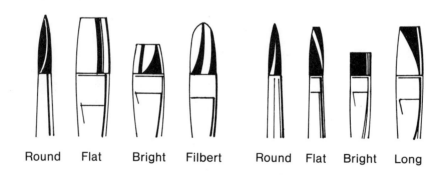

Round Flat Bright Filbert Round Flat Bright Long

BRISTLE OIL BRUSHES **SABLE OIL BRUSHES**

The four basic styles of hog bristle oil brushes are round, flat, bright and filbert. Sable brush shapes are available in round, flat, bright and long.

are firm and strong. They produce expressive strokes in which it is even possible to see the furrows left by the pressure of the bristles. This is essential for painting backgrounds and broad areas, and for stipling and shading, whatever the size of the area.

Sable brushes are more suitable for a smoother style where the coats are even and flat. They are also used for drawing outlines and coloring small shapes or details, and for fine lines. For instance, after painting the lips in an oil portrait with a bristle brush, you should use a sable brush with a good round point for adding the fine lines in the flesh and the gap between the lips. You can also make dark lines around the eye to represent eyelashes and other details of the face.

Hog bristle brushes are made in several different shapes: *round, flat, bright* and *filbert.* Sable brushes are made in *round, flat, bright* and *long* shapes. The figure opposite illustrates each of these types.

Round brushes are generally used for painting lines. *Flat brushes* are probably used most because they can be used flat with broad strokes or on edge to produce lines and outlines. This is also true of *bright brushes*, which have shorter bristles, but I find them more suitable for a smoother style of painting. *Filbert brushes* are more rounded or curved than a flat brush, and are shaped like a cat's tongue. *Long* sable brushes are shaped like flat hog bristle brushes.

A brush consists of a *handle*, a *ferrule* and the *bristles.* The ferrule is the metal part which encloses the bristles and attaches them to the handle. The handle is longer on oil painting brushes than on brushes for watercolors. Their length varies between 10-1/4 and 11-3/4 inches. This greater length is needed because when you paint in oils, you usually work on a practically vertical surface and nearly always stand some distance from it so you can see not only the area being painted but the entire surrounding surface. The long handle enables you to hold the brush at a point farther from the bristles, which makes it easier for you to stand away from your canvas and get that broader view.

The thickness of the bunch of bristles and, in fact, the entire brush varies according to the number on the handle. These numbers run from 1 to 22. Except for No. 1, they are designated by even numbers, 2, 4, 6, 8, 10, and so on. The illustration on page 21 gives a full-scale illustration of the complete range of flat brushes.

BRUSHES COMMONLY USED BY PROFESSIONAL ARTISTS

SMALL ASSORTMENT

1 flat No. 4 hog	1 flat No. 6 hog
1 flat No. 12 hog	1 round No. 4 hog
1 round No. 4 sable	1 bright No. 8 hog

LARGE ASSORTMENT

2 flat No. 4 hog	2 flat No. 6 hog
1 flat No. 8 hog	1 flat No. 10 hog
2 flat No. 12 hog	1 flat or bright No. 14 hog
2 round No. 4 hog	2 round No. 4 sable
1 round No. 6 sable	1 bright No. 8 hog

You will probably not need such an extensive range. It is advisable, however, to have two or more brushes of the same number. The lists above are a common assortment that will let you use all of the techniques in this book. The larger assortment is for when you feel you are ready to experiment on your own.

CARING FOR YOUR BRUSHES

Brushes are expensive, so you will want to take care of them. But cost is not the only reason. A brush that has been used and kept in good condition paints better than when it is new.

The main point is to keep them clean so that the bristles retain their shape. This is so important that the bristles of new brushes are oiled with a solution of glue or gum arabic so they will hold their shape. If this solution is too thick and the bristles really stick together, they must be dipped in lukewarm water before you can paint with that brush again.

You do not need to worry about cleaning your brushes while you are painting. The paint is soft and the brushes are constantly being used on the picture. But never allow oil paint to dry on your brushes. Try to get in the habit of cleaning your brushes after each painting session. If the session is broken off overnight, you can probably start again without cleaning your brushes. But if a day elapses, or if the picture has been completed and it may be two or more days before you paint again, then you must clean your brushes thoroughly until they are like new. There are basically two cleaning methods: with turpentine and with soap and water.

A range of brushes. These are the flat sable type shown in actual size.

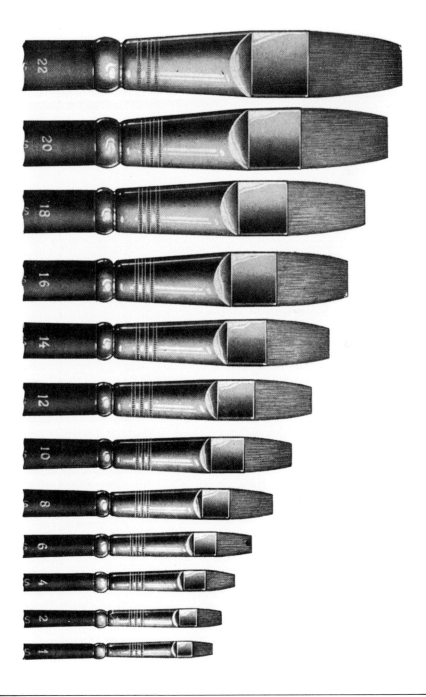

Cleaning with Turpentine—First dry your brushes with a rag, wiping off any excess paint. Then dip them in a jar of ordinary turpentine, not essence of turpentine which is very expensive. Rub the bristles against the side of the jar, rinse them with water, dry them and wipe them again with a rag. Continue dipping, rubbing, rinsing and drying until they are clean.

After being cleaned in turpentine, the bristles will be rather taut, especially in the case of brushes made with bristles from young hogs. They will be inclined to separate, rather like an old broom. To prevent this, you can wash the brushes with soap and water after they have been cleaned in turpentine; this will leave the bristles softer and more compact.

If you want, there are special jars on the market for washing brushes. They have a wire screen about half way up the inside. You fill the jar with turpentine to just above this screen and then rub the brush against it until it is clean. The sediment of color removed from the brush sinks to the bottom of the jar.

Cleaning with Soap and Water—This method is very common, easier and more pleasant, and still gives good results.

First, wipe off the leftover color with a rag, removing as much paint as possible. Then, in the bathroom or kitchen, rub the brush on a piece of soap, as if you were going to paint with soap. Wet the brush under the tap and then wash it, rubbing it on the palm of your hand. The soap will immediately produce thick suds tinted with the color from the brush. Rinse the brush with water and apply it to the cake of soap again, loading your brush with soap. Wash it once more by rubbing it in your palm and rinse it again. Each time you repeat this the suds will be cleaner until they become completely white. One last rinse under the tap and you're finished.

If you are inexperienced, the only danger with this method is that when you rub the bristles in your palm, you may bend them and cause them to lose their shape. To prevent this, rub as if you were painting. Rest the head of the brush on your palm and make a small circular movement, always dragging the bristle behind the ferrule. You can safely rub them as hard as you like. Try it! It's easy.

Finally, with either method, once the brush is clean, you must dry it carefully. If it remains damp, the ends of the bristles held by the

ferrule can become unstuck. Store your brushes in a jar with the bristles and ferrule up. This is the usual way of keeping brushes in a studio when the artist is not painting.

PALETTE KNIVES

Palette knives have a dull flexible steel blades and a wooden handles and are available in different shapes. They are used to mix colors or to paint with like a brush.

In oil painting, palette knives are used for several purposes. You can clean an area where a mistake has been made while the paint is still wet, a process called *rubbing out*, and you can clean the leftover paint off the palette when the session is over. A palette knife is also used to mix paints on the palette and in painting.

Knife-shaped palette knives are best for scraping a canvas. Use the thinner end of a flexible blade for correcting and rubbing out. A firmer blade is preferable for cleaning the palette. They are sometimes called *spatulas*.

When used for painting, flexible trowel-shaped blades are commonly used. The palette knife is used the same way as a brush, except that much larger amounts of paint are delivered to the canvas. The technique of palette knife painting will be covered in another volume in this series.

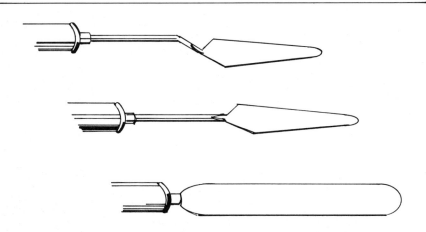

These are three types of palette knives commonly used with oils. The trowel-shaped blades are used for painting. The spatula is used for scraping.

SURFACES FOR OIL PAINTING

The customary surfaces for oil painting are canvas, wood panels, pasteboard and paper. Anything can be painted on with oil as long as it isn't too rough, is not liable to shrink, stretch or warp, and is not too absorbent. In the exercises in this book I advise you to use paper. It is inexpensive and you can afford to make mistakes.

Canvases—These are the most common surfaces because of their elasticity, light weight and flexibility.

Good fabrics for oil painting are linen, hemp and cotton. The roughness of their surface varies according to the warp and thickness of the threads. There are *fine*, *medium* and *large grained* canvases. Fine grained ones are best for a delicate style while the large grained surfaces call for a bolder impressionistic handling. Medium grained canvases are used most often.

For oil painting, canvases are sold *primed*, or prepared, which provides better cohesion and permanence of the colors. This priming, which is applied only to one surface, consists of a coat of glue mixed with plaster. It is usually white. Some canvases and other supports are primed with a colored mixture producing a smooth coat of neutral gray, bluish gray or reddish sienna. The choice of a prepared colored undersurface, such as these grays or sienna, is dictated by the artist's preferences. Many old masters painted on canvases which had already been color primed. For example, Rubens painted on gray and Velazquez on reddish sienna. You can also buy your canvas *unprimed*, which is less expensive, and prime it yourself following the directions on pages 26 and 27.

Canvas can be bought mounted on a *stretcher* or board, or as unmounted pieces which are sold by the yard. The size canvas you select really depends on subject matter and personal choice. Most artists stretch their own canvas to the exact size they want. Unmounted canvas is usually 28 to 60 inches wide and is suitable for fitting on a stretcher. Mounted canvases are available in many sizes. The one absolute requirement for canvas is that it be drum tight. If you snap the surface of a stretched canvas with your fingers, it should "ping." If it does not, the canvas is too loose. A loose canvas will vibrate as you paint it and make your painting sloppy.

Using a Stretcher—A stretcher is a wooden frame that holds your canvas taut. You can buy four *stretcher strips* already cut at the ends for a smooth fit. When you fit your stretcher together, be sure the corners form precise 90-degree angles.

The piece of canvas should be about 1-1/2 inches longer than the stretcher on all sides. Roll the canvas out on a flat surface with the primed side down. Center the stretcher on it. Fold the canvas over one end of the stretcher and tack or staple the canvas to the center of the edge.

Move to the opposite end, pull the canvas tight and drive another tack or staple through the canvas into the wooden stretcher. Repeat this on the other two sides.

When you have all four sides tacked to the center of the edges of the stretcher, tack or staple along each edge but do not staple closer than three inches to each corner. Leave about three inches between each tack. Smooth all wrinkles as you position your tacks or staples.

When the edges are secured, finish the corners by folding one side under the other and driving a tack or staple into the stretcher to hold canvas in place. Trim excess canvas, or fold under and tack it.

Now that the canvas is mounted, you need to stretch it. Small wooden wedges are driven with a hammer into the inside angles of the corners. This enlarges the stretcher and stretches the canvas.

Check the canvas by snapping it with your finger. If it "pings" you've done a good job.

Panels—Wooden panels were commonly used as supports by painters before the Renaissance. At that period panels required special construction and preparation, but now modern thin plywood or untempered Masonite provide the artist with permanent, lightweight, rigid supports. Both are cheap, need no stretcher or backing, and can be cut to any size or shape. They are permanent and easily obtainable at any lumber yard. They can be used primed or unprimed, although most artists prime their panels as a matter of course. A 3/16-inch plywood or Masonite panel primed with a coat of gesso or diluted carpenter's glue is suitable for painting.

Cardboard—This is used for painting preliminary sketches and small pictures. You can buy prepared cardboard with white, smooth matte priming. Like wood, cardboard can be prepared at home simply by applying a coat of priming, but make sure that you coat both sides to prevent warping. Cardboard absorbs liquids easily. Good quality, thick, well pressed, gray cardboard can be used with no preparation except a coat of oil paint from the tube thinned with essence of turpentine. This reduces the absorbent quality of cardboard. The coat must be completely dry before you start to paint. Cardboard is also sold primed in art supply stores.

Paper—Surprising as it may seem, paper is also an excellent support for oil painting. Rubens and other old masters used it for drafts and sketches. It was also used by the impressionists for painting preliminary sketches which were then worked up into finished pictures.

It is essential that the paper be thick, very good quality and well primed. Canson brand or fine grained watercolor paper is excellent. No preparation is required. You can paint directly on it. Because the paper is so fragile and liable to contract and expand, it is not advisable to paint finished works or large pictures. Paper is excellent for studies, sketches and rough notes. You should use paper for all the exercises in this book.

Priming—If you select a support that is not already primed by the manufacturer, the next step is to prime the surface. *Gesso* is a plastic or liquid paste applied to the surface to prepare it for receiving the oil paints. It is a mixture of a pigment and a solution of glue. Polymer gesso can be bought at art stores to prime panels or raw linen. It is

sold ready to use. It is applied in two thin coats with a wide house-painter's brush. Allow the first coat to dry completely before applying the second coat. When dry, the surface is sandpapered to a smooth finish and you are ready to paint.

If you do not have gesso available, you can mix the following ingredients in a small jar and paint an even coat on the cardboard using a flat No. 8 brush. Apply a second coat without waiting for the first to dry.

10 to 12 drops of essence of turpentine
3 to 4 drops of linseed oil
1 portion of white paint
1/3 portion of burnt umber

As you can see, this formula is not precise. We are trying to produce a grayish light sienna oil paint, diluted with some essence of turpentine and one third of that amount of linseed oil so that the paint is thick enough to cover. To test the thickness, load the brush and hold it in the air to see whether the paint stays on it without dripping. If it does, it is the right thickness. The grayish light sienna must be more or less the same as the background in the illustration on page 59. Add more white or umber until you come close to this tone.

PALETTES

Traditional palettes for oil painting are oval or rectangular. Made of wood, china or plastic, every type has an elliptical hole at one end with beveled edges shaped perfectly for the thumb of the left hand. Near this hole there is an indentation which is shaped and positioned so the palette can be held by the index and middle fingers.

Before you make your choice, hold a palette, test it, feel it in your hand resting on your forearm.

Palettes for oils are usually either oval or rectangular. Choose whichever suits you best.

In the studio, I prefer an oval palette, but, when painting outdoors, I use a box palette which is rectangular.

I use only wooden palettes, however. I feel that a china or plastic palette is out of place in an artist's studio. But that is a matter of taste. Make your own choice.

What size? The size corresponds to the size of the picture being painted. Most painters keep two or three palettes in their studio: a small one used for notes, sketches and small pictures; a medium for medium-sized paintings, and a large one, which is used for large pictures. The larger the palette, the more space it contains and the more paint it can hold.

Your palette should be cleaned when the work is finished. But sometimes you may want to leave some color on it so, when you begin a new painting the next day or the day after, you can use these leftovers. Nevertheless, it is nearly always best to clean the palette thoroughly so that you can begin your new work with fresh color straight from the tube. To clean your palette, scrape it with a palette knife, then wipe it with newspapers. When most of the paint is removed, rub the palette with old rags and finally with a rag slightly moistened with turpentine.

Palette Pads—These are tablets of a specially treated paper cut in the traditional palette shape. They can bought in art supply stores and are inexpensive. Clean-up consists of tearing off the used top sheet to reveal a clean fresh surface underneath. The used top sheet can be thrown away.

MEDIUMS

Oil paint straight from the tube is nearly always too thick for painting properly. To dilute it for applying, the artist uses what are called *mediums*. These are liquid solvents used for thinning the paints. Use these solvents very sparingly, though.

Essence of Turpentine—This is the best solvent. It dries quickly through evaporation. When mixed with oil colors, it accelerates the drying process and makes it easier to add additional coats. This is especially useful when painting sketches which have to be completed in one or two sessions.

However, use very small amounts to avoid diluting the color too much. This can destroy the adhesive quality of the paint.

Essence of turpentine gives colors a *matte* quality which does not shine and is highly esteemed by some contemporary painters.

Linseed Oil—This is another commonly used solvent, but it is rarely employed unmixed. Oil color straight from the tube already contains a considerable quantity of linseed oil. If it is diluted with yet more oil, the resulting mixture becomes greasier, which obviously delays drying. For some subjects and techniques this can be an advantage because it makes it possible to paint over comparatively soft coats applied at the previous session.

When the picture is completed, the paint mixed with linseed oil produces the traditional shiny surface of oil paintings. However, this shine may be uneven because some colors dry more rapidly than others. To solve this problem, it is best to varnish the picture when it is finished and dry.

Mixed Solution—One of the classic solvents for oil paints is a mixture of essence of turpentine and linseed oil. The proportion used in this mixture is governed by the subject, which may require rapid or slow work, the support's absorption capacity, and the finish, which may be shiny or matte.

Dryers—These are also used as solvents for accelerating the drying process. It is advisable to use them only in special cases.

PALETTE CUPS

These are small containers for the solvents, essence of turpentine and linseed oil. The classic model consists of two small metal cans with a catch at the base for attaching them to a palette. When working in the studio, it is common practice to use any container as long as it is small and shallow. A shallow glass with a wide mouth, a china or porcelain jar or an ashtray will work well. Baby food jars are excellent.

RAGS

You'll need lots of rags. They are used for drying brushes, for cleaning them when changing from one color to another, for rubbing out on the canvas and for cleaning your palette. Any type will do.

STUDIO EASEL

The figure on the facing page shows three types of studio easels. The first (A) has a simple frame and is commonly used in art schools. Notice that the shelf for holding the canvas can be raised or lowered by using the toothed bar set in the central support (b). This is the least expensive of the three types.

The second style (B) is probably the most popular for professional studios. This type is very solid. It can be moved easily on its castors. The shelf for the canvas can be raised or lowered, and an attachment (c), which is also adjustable, can be fixed to the central support to hold the canvas or stretcher at the top.

Finally, type (C) is a deluxe model which includes two shelves for holding small and large pictures, a central support which can be inclined to facilitate work on large canvases, and a board which can also be adjusted for drawing and painting small sketches. Needless to say, this is the most expensive model.

AND AN EXTRA PIECE OF FURNITURE

When you start painting you need only arrange and keep your tubes of paint, jars of solvents, oil jars, palette knives and brushes in a box similar to those described on page 32. But if you want to set up a proper studio, you should consider obtaining a small table. It should have castors so that you can move it easily, and a washable top such as Formica. It should have enough drawers for storing your tubes, brushes, jars and other equipment. The most convenient height is 24 to 28 inches.

OTHER SUPPLIES

As you practice you will find these other supplies useful: charcoal pencils, carbon pencils, a drawing board for when you paint on a small sheet of paper or cardboard, pushpins, a sketch book and a can or bottle for the turpentine for cleaning brushes.

EQUIPMENT FOR PAINTING OUTDOORS

The only special equipment you really need for painting outdoors is a box for carrying and keeping materials, an outdoor easel and a stool for sitting down when you get the chance.

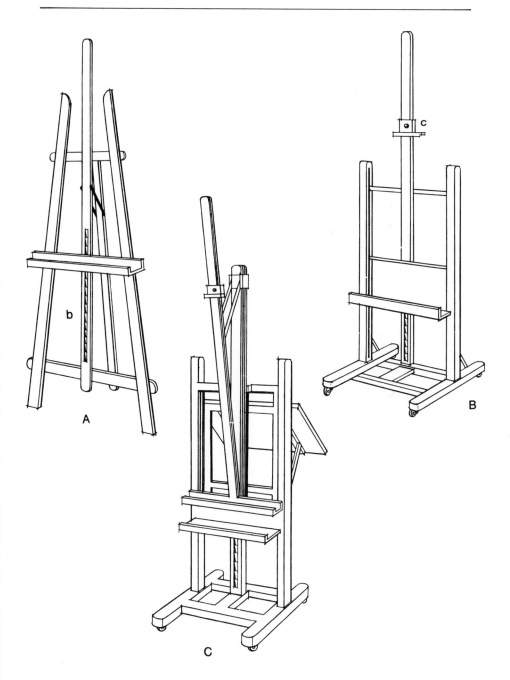

This page shows three types of easels for studio work. Type A, the simplest of the three, is commonly used in art schools. Type B is most commonly used in professional artist's studios. Type C has a number of advantages, the most obvious being the drawing board at the back which can be slanted for drawing or painting small sketches.

BOXES

Special boxes are available in various sizes. They are usually made of wood and contain compartments for storing the tubes of colors, brushes, palette knives, jars of solvents, oil jars, rags and miscellaneous equipment. Every type also contains a palette designed to fit into the box. Most boxes have small metal clips that hold the palette without letting it touch the base of the lid which allows you to carry the palette without having to clean it first. Some models have similar arrangements for carrying newly painted cardboard sheets when they are the same size as the inside of the lid. The quality and price of the boxes are determined not only by the size but also by the construction and finish. Ordinary fishing tackle boxes are less expensive. Their divided trays are excellent for holding supplies.

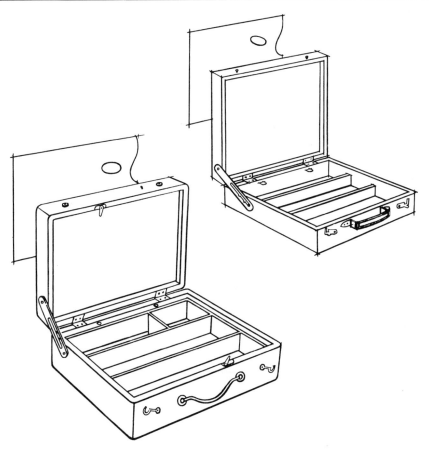

Boxes for painting have various shelf arrangements and usually have a palette which fits into the lid.

OUTDOOR EASELS

These consist of a wooden tripod designed to be folded up for carrying. There are several different types but choose one that is lightweight and solid. When it is set up, it must be high enough so you can paint standing if you wish, but it should be adjustable for painting when sitting. It must be possible to fix the picture firmly at the top so that, as far as possible, it is immovable.

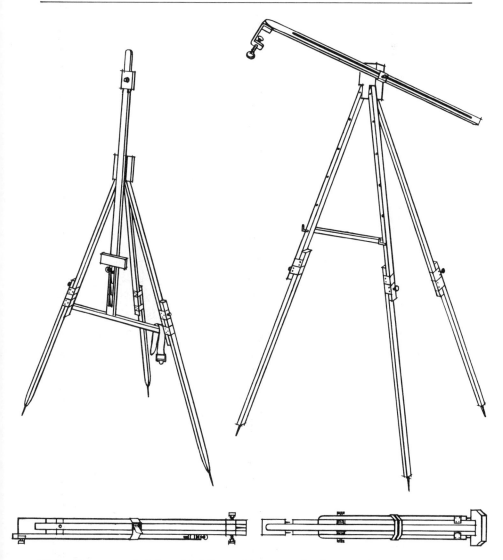

There are several styles of folding outdoor easels. Be sure the one you choose will hold your canvas securely.

COMBINED EASEL AND BOX

There are easels available which have a built-in box that can be set up and taken down in a minute, yet still provide a solid and really practical unit.

Look at the illustration below and notice the number of adjustments which can be made when it is set up, particularly in type B. You can slant the picture, holding it with the lower shelf and the hooks at the top which can be adjusted to hold any size surface. And you can lower or raise the whole unit by sliding the legs. Notice too that when it is folded, it is even smaller than the ordinary box. Too bad it's so expensive.

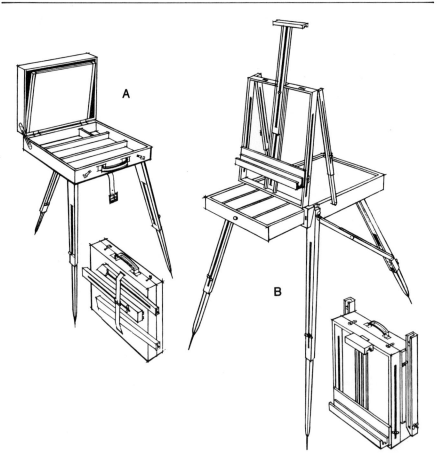

Combined easel and box is very suitable for painting outdoors because you only carry one item instead of two.

STOOLS

Look at stools, but if you aren't bothered by carrying a pound or two more, I would advise you to buy a folding metal camping chair. They are firm, light and much more comfortable than a stool. I consider this rather important. In an intellectual job like painting, physical comfort influences the final results.

STRETCHER CARRIERS

These are a simple but essential item for carrying a newly painted picture. They consist of two metal clasps attached to a metal strip. Each end of the metal clasps has a screw so that a canvas or stretcher can be fixed to each side of the strip. The strip holds the two canvases apart. So you need another stretcher and canvas of about the same size to carry a newly painted picture. One clasp has a handle attached for carrying as shown below.

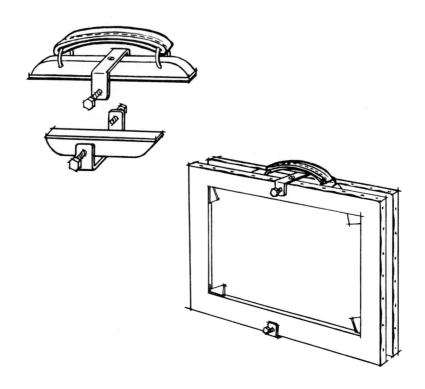

Stretcher carriers enable you to carry a newly painted picture without risk of damage.

2 PRACTICE WITH OILS

Painting with Two Colors
Painting a Cube
Painting a Sphere
Painting a Jug
Painting a Still Life

BEGIN WITH ONLY TWO COLORS

In teaching the techniques of oil painting, I shall follow the traditional method of most art schools. In learning anything new it is best to start with the basics. However tedious this seems, you will soon learn that freedom in painting develops with a complete understanding of your medium.

First you will practice and paint with only two colors, or rather one color and white. Then you will work with three colors, the primaries, blue, red and yellow. Finally you will use every color.

This method assumes that you have never painted with oils before. I take it that you know nothing about the fluidity, softness, covering power and drying times of the colors. Nor do you know about the potential of that softness and opacity which an artist can use to cover, outline and trim, drawing while he paints. I assume that you are also unaware of the natural properties of that softness under the influence of an expert brush which shades, models, depicts and paints the form, producing that synthesis of form which we so much admire in the old masters. But first things first. Do not confuse this introduction to skillful handling with the real problem of painting, learning to see and mix colors.

So, we shall take our first steps with only one color and white. At this stage, it is usual to paint with black and white, but we shall use

white and a very dark burnt umber. It is almost as dark as black but is pleasanter, warmer and more chromatic. And it is nicer to work with than a cold, monotonous black.

Your first practical exercises will be to paint a cube, a sphere and a jug using only these two colors but without working from a model. This will enable us to test the medium and also to see how the palette is used, how the brushes are held, how to hold your brushes.

Later you will advance to the three primaries and learn that every color in nature can be made up from just those three.

MATERIALS

Titanium white	*Palette*
Burnt umber	*Essence of turpentine*
Flat No. 4 hog brush	*Linseed oil*
Round No. 4 hog brush	*Oil jars or small containers*
Round No. 8 or 10 sable brush	*Thick Canson paper or cardboard*
Bright No. 8 hog brush	*Rags, pins, pencil*

I have not mentioned an easel because I assume you have one already. But don't worry if you don't have one for these early exercises. For the time being, you can simply use a chair, resting a drawing board on the seat and leaning it against the back. Pin the Canson paper or cardboard to the drawing board with pushpins as shown in the photo below.

This is the position I paint in. Here I've set a board on a chair. Notice how far I am from the paper.

HOLDING THE PALETTE, BRUSHES AND RAG

See how the palette, brushes and rag are held in the illustrations below: all in the left hand, leaving the right free for painting. Try holding your equipment the same way while examining these pictures.

The palette is held mainly by the thumb which, either by itself or with the help of the other fingers, can keep it at a slightly oblique angle and away from the forearm, as in A, or horizontally, resting it on the forearm which helps to take the weight as in B.

In figure C, notice how the brushes are held to form a fan shape so that the paint on one does not rub off on the others. Notice in figure D how the artist holds the palette, brushes and rag in his left hand.

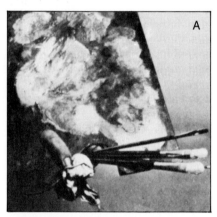
Palette held away from arm.

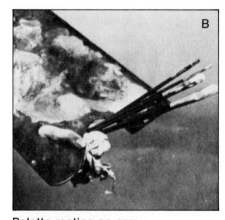
Palette resting on arm.

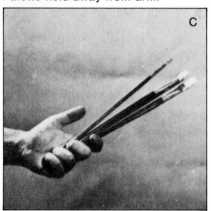
Brushes held so they don't touch.

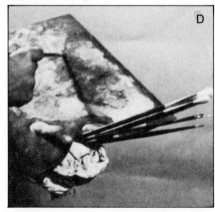
Holding the rag and brushes.

The method shown in D is the usual way of painting outdoors. When working in the studio, some artists prefer to place the palette on a chair or small table in front of or beside the easel. The weight of a large palette can be tiring for a session lasting an hour or more. With this system, only the brushes are held in the left hand. The rag is also placed on the table beside the palette.

USING THE BRUSH

As we said earlier, brushes for oil painting are produced with longer handles than those for watercolors or other techniques. This is because they have to be held at the tip or two thirds of their length away from the bristles, as shown in the illustrations on page 40. This is because of the distance which the artist must keep from the picture when he is painting. Let me emphasize this important rule: Oil painting requires that you stand *away* from your picture. This can be 3 feet or more depending upon the size of the picture.

You paint by stretching your arm and holding the brush by the end of the handle.

"But why?" you ask. Well, there are many reasons. More than any other technique, oil painting requires that you have a full view of the picture at all times so that you can see and paint simultaneously. You must be able to move from area to area without being held up at any particular point. Also, this distance induces a smoother, more impressionistic technique. You will find that when you hold the brush by the upper end, the range of the head is much greater than if you hold it by the ferrule. This wider range encourages broader strokes and induces a spontaneous touch.

This does not mean that on occasion you will not move your hand down to the ferrule. You will have to do this when you need to paint details such as the light in an eye, the exact shape of a nostril or the line between the lips. We shall discuss these brushstrokes later, but let me tell you that for these minute touches an artist often uses a *mahlstick*, a long stick tipped with a ball wrapped in a piece of cloth. This is used to rest your hand on while working. It keeps your hand steady and helps to keep you from accidently touching the wet painted surface. This technique is described in more detail on page 126.

HOLDING TECHNIQUES

There are three common ways of holding a brush: like a pencil, either with your hand straight or with it turned a quarter-turn, or with the handle along your palm.

Try both positions with a flat No. 8 hog brush and paint on paper. See how holding the brush like a pencil allows you to paint in every direction, upwards and downwards, using vertical or diagonal strokes. You can also paint horizontally by revolving the brush from left to right or vice versa.

Notice too that the brush is perpendicular to the surface of the canvas or cardboard. This is an important detail which strongly affects your stroke.

In this position, the tip of the brush is applying the color rather than the body. If you want to paint a dot, a thin line or a bright spot, you need only apply the brush to the right area. But if you want to make a broad stroke, you must apply pressure and bend the bristles, which makes the stroke firmer, harder and more clearly defined.

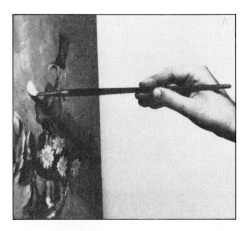 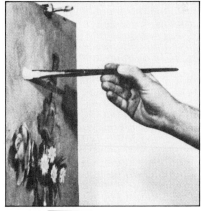

Hold the brush like a pencil for controlled strokes. For flatter strokes, turn your hand a quarter turn.

You will already have realized that by using this method you can paint and mix colors, working on an area which is still wet. Or you can apply color by rubbing or scraping the bristles of the brush over a dry surface, using a strong shading movement. This is the best method for shading, by applying the tip, bending the bristles and darting the brush in a quick movement. It is also suitable for applying color in the pointillist style and then blending it with the previous coat while it is still wet. You can also use this method for giving a firm outline to a shape and for painting with strong, firm touches.

If you turn your hand a quarter-turn, the brush remains slightly at an angle to the surface. The stroke is flatter, the bristles offer less resistance and, as they do not have to bend as before, you can paint more smoothly and less forcefully.

This method produces a smoother stroke. It is essential for blending and shading on wet areas, for tinting a color and for putting in outlines. But in every case, your stroke will have less strength and less effect upon existing colors or forms than the first method.

Holding the brush with the handle along your palm automatically means that the brush has to be held closer to the bristles, nearer to the middle of the handle. This produces a broad, very free style, unsuitable for small details.

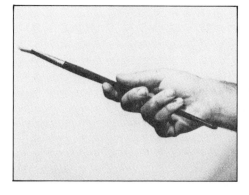 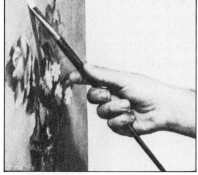

Hold your brush with the handle along your palm for broad effects.

When you hold the brush in this way, it forms a much smaller angle with the surface. The tip of the brush can even paint lying flat along the surface. The stroke is not governed by the bent bristles as it was in the first position. Instead of making strokes, you place the brush on the suface, *depositing* color.

With this method, you can apply color without blending it with previous coats. You can paint a white line on a dark, wet area without allowing the wet paint to dirty the white. You can gently place color upon color, or soften a hard edge or a too firm outline with the clean brush.

You should learn and master all three methods until you automatically apply them whenever they are needed. The ideal is not to think about how it is done, but only about what you are doing.

ARRANGING THE COLORS

Take the tubes of white and burnt umber. Squeeze out some of both on your palette, placing the white on the top right side and the burnt umber to the left of it. At the beginning, there should be about twice as much white as umber.

We should mention in passing that, when you work with all the colors, you will set them out on your palette in a specific order. The general rule is to put the lightest, headed by white, on the right and the darkest paints to the left. They are placed around the edge of the palette so that the center is left clear for mixing. The figure below shows how I arrange my own palette.

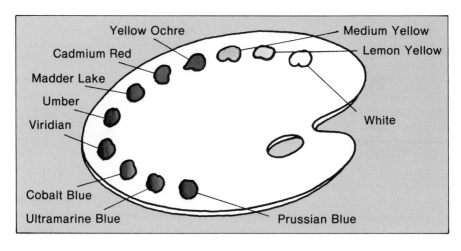

Painting A Cube

You can now begin to paint in oils without needing to know anything more. Our first exercise is to paint a cube in oils. One small piece of advice: *Do not be afraid of making mistakes.* The hardest moment is the first moment you apply paint. Go ahead. You'll never learn if you don't try.

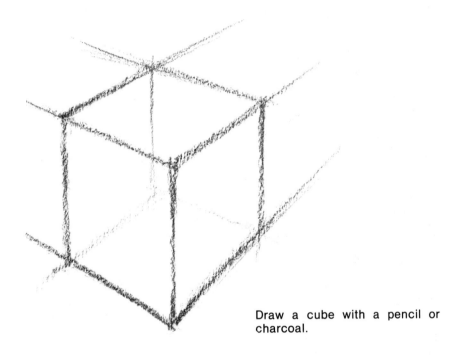

Draw a cube with a pencil or charcoal.

First take a good pencil and draw a cube on a separate piece of paper. If you can make a perfect drawing from memory of an oblique view of a cube, you can omit this exercise and start painting. Bear in mind that while you are painting the cube, you must be seeing an image of it, noting the position and exact size of each edge, the proportion between the faces, and so on. Think of your painting as a film projection of a perfectly formed and drawn cube: an image which must be firmly fixed in your mind's eye. This is the only way you can paint a perfect cube.

If you choose not to draw a cube on a separate piece of paper, at least look at the series of drawings on the following pages and study them.

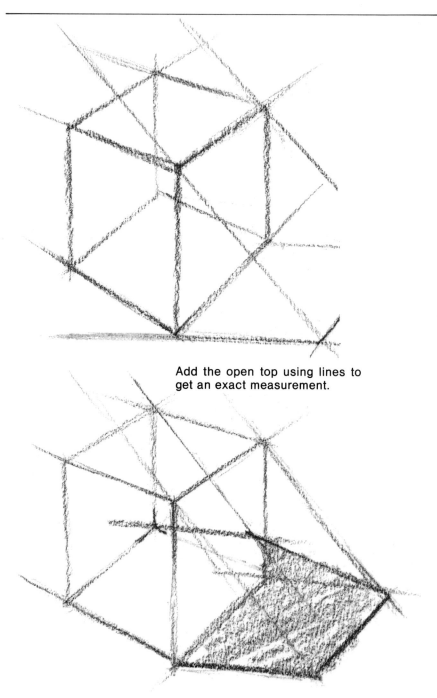

Add the open top using lines to get an exact measurement.

Add shading so you can see the planes of light or shadow.

COMPOSITION

MATERIALS

Titanium white

Burnt umber

Flat No. 4 hog brush

Round No. 4 hog brush

Bright No. 8 hog brush

Essence of turpentine

Rag

Be careful with the turpentine. Simply wet the flat No. 4 brush in the jar of turpentine and apply it to the paint so that, with the help of this moisture, you will produce a fluid, but not runny paint.

Paint an outline sketch of a cube in two dimensions without following any preliminary pencil lines. Simply draw directly on the white paper with your brush and the burnt umber.

Composition

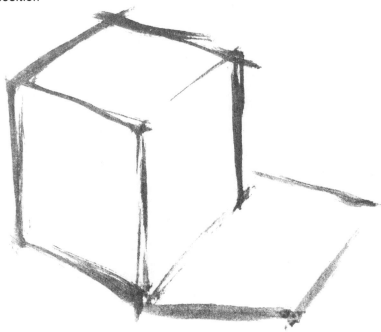

FIRST STAGE

With the same flat No. 4 brush, paint the dark area of the shadow cast by the cube with the burnt umber, straight from the tube as shown on the next page.

Still using the same color, paint the dark patch surrounding the illuminated face of the cube.

With the same brush, add some white to the burnt umber and paint the shadowed face of the cube.

Now take the No. 8 brush, mix the light umber of the front face of the cube and paint it. Use plenty of paint and apply it thickly.

Now darken the background. Use the No. 8 brush and take a touch of umber, but darker than the previous tone. Paint with strong strokes. Mix a little white on the surface of the paper and lighten the area marked *a*, bordering the shadow behind the cube.

First stage

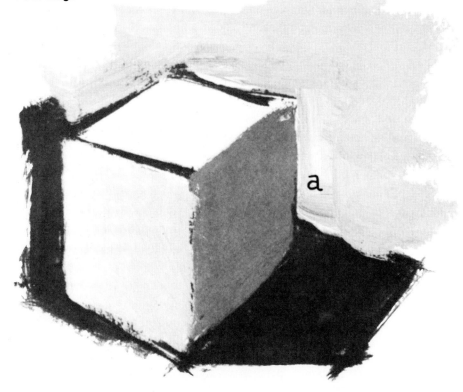

THICK OR THIN PAINT

In principle I would say use a thick, *impasto* paint which shows the material and the strokes. Thickness depends on the amount of solvents used, whether essence of turpentine or linseed oil.

How much essence of turpentine should be mixed with the pigments to produce a thick, paste-like paint? It depends, of course. Generally speaking the small amount picked up by the brush when the tip is dipped in the essence of turpentine is enough. Even less than that can be used when the paint from the tube is already oily and not very thick.

To produce a modern finish with thick paint, use very small amounts of solvent or even none at all, especially when the paints from the tube are already fluid and oily.

DON'T BE AFRAID TO FAIL

Try to use a lot of color and thick paint, especially in the lighter areas. Work carefully and attentively, calculating and studying each step, but as boldly and strongly as you can. When you are actually painting work rapidly, freely and fluently. Then stop, relax and study what you have done. Examine your work carefully and take your time planning what you must do next. Then start again with enthusiasm and paint bravely and boldly.

ONE BRUSH FOR EACH COLOR

When using every color, you generally keep four, six and even eight brushes in your hand, one or two for the dark colors, two or three for the reds and siennas, another two for the yellows, one for very light colors and white. In any case, whenever you have to mix a new shade or color, you must clean the brush first with the rag. To make a brush really clean, you can dip it in essence of turpentine.

SECOND STAGE

Continue working on the background, spreading the grayish medium umber until you finish it. Use plenty of very thick paint.

When you have finished the background, you will see the reason for the dark patches you painted in the first stage which outline the highlight areas of the cube. In fact you will see that the dark color reminds you how useful it is to contrast and strengthen the border areas so that the light tones acquire more power. It also suggests the possibility of leaving a narrow strip of this dark color as a means of outlining the shape, but without forming a clumsy line which is so often used by a beginner to give shape and outline to a form.

Paint the top surface of the cube, which is the lightest color, using the round No. 4 brush. This will allow you to go right into the corners.

Now for the finishing touches. First blend the tones by repainting if necessary. Do not emphasize the outline too much and do not paint with bent bristles. Hold the brush in your palm and use a well loaded brush so that it produces dragged brushwork like that along the edges

Second Stage

of the shadow. Whiten the light areas of the background where it joins the shadowed face. Darken the nearest edge of the shadowed face and shade it so that it fades toward the background. Finally, try to give life to the initial dark lines with which you drew the cube.

Examine the direction of the brush strokes and see whether they bring out the form of the cube without being regular and mathematically precise.

Painting A Sphere

This exercise is not much different from painting a cube, but it will help you explore tonal values.

COMPOSITION

MATERIALS

Titanium white　　　　　　　　Bright No. 8 hog brush
Burnt umber　　　　　　　　　Essence of turpentine
Flat No. 4 hog brush　　　　　Rag
Round No. 4 hog brush

Composition

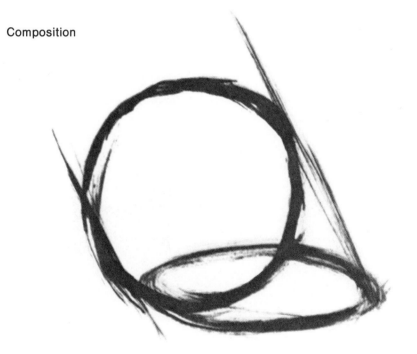

Draw a circle directly on your surface with your flat No. 4 brush and burnt umber as you did with the cube, but dilute the paint with a very small amount of essence of turpentine. Remember that if you use too much essence of turpentine, the paint will run and spread, producing oily patches on the paper.

FIRST STAGE

Still using the flat No. 4 brush and thick burnt umber, paint the shadow cast by the sphere and the shadow formed on it. For the shadow, use an almost dry brush, sketching in the form with the dragged strokes shown in the illustration below.

Now deal with the background, applying white mixed with a very small amount of burnt umber. Work with a lot of paint and a well loaded bright No. 8 brush.

First stage

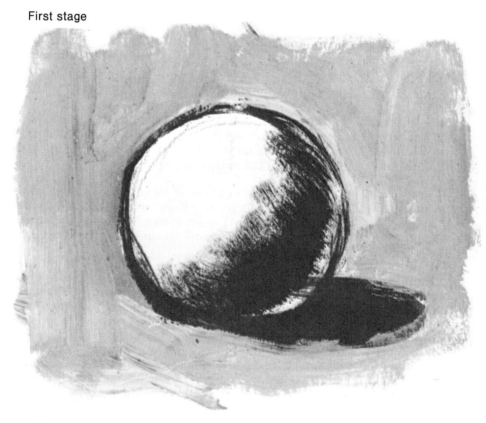

SECOND STAGE

Outline the sphere with the No. 8 brush, first using a medium umber made by adding white to the umber. Paint the medium-toned area surrounding the highlight with circular strokes. Then blend that grayish medium sienna with the dark umber of the shadowed area. Finally, paint the highlight and lightest section of the sphere with white using the round No. 4 brush.

You are now working with one brush for each tone. The flat No. 4 is used for dark tones, the round No. 4 for highlights and light tones, and the bright No. 8 for the intermediate tones. The No. 8 will play the most important part, blending and shading, drawing and outlining.

Second stage

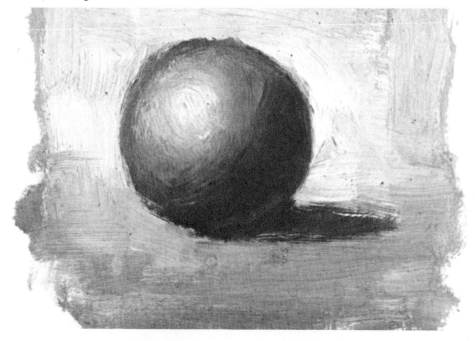

Back to the background. Do not spend all your time on modeling the sphere until it is perfect. There is nothing worse than concentrating on one area, going over and over it without paying any attention to the rest. Notice how the background outlines and brings out the shape in the illustration above.

Now the finishing touches. Return to the sphere with clean brushes and paint the line of reflected light along the edge of the shadow. Apply pure white in the highlight and very smoothly, without any dragging, work on this highlight until it is blended into the grayish sienna of the intermediate area.

Study the direction of the brush strokes in the illustration above. Be sure that your background is not worked in only one way so the strokes on the sphere are circular and ground appears to be formed horizontally.

Painting A Jug

PRELIMINARY DRAWING

Make another drawing in soft pencil on a separate piece of paper. This time you must study the jug which is to serve as the last model for these preliminary exercises. The two drawings below give an example of what yours should look like.

I am asking you to do this so that later you can paint more fluently with a firm mental image of the structure and form of the model. If you can draw this jug perfectly, you can also paint it perfectly.

COMPOSITION

MATERIALS

Titanium white	Round No. 4 hog brush
Burnt umber	Bright No. 8 hog brush
Flat No. 4 hog brush	Essence of turpentine
Flat No. 8 hog brush	Rag

Preliminary drawings

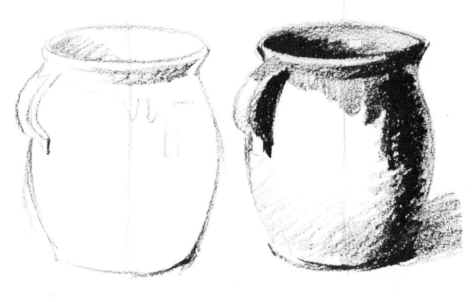

On another sheet of paper, sketch in the shape of the jar using the flat No. 4 brush used sometimes flat on the paper and sometimes on edge. Apply burnt umber slightly diluted with essence of turpentine. Try to produce an accurate drawing but don't worry if it is slightly misshapen. As long as you can reconstruct by redrawing to produce a final perfect composition, there is no problem.

Composition

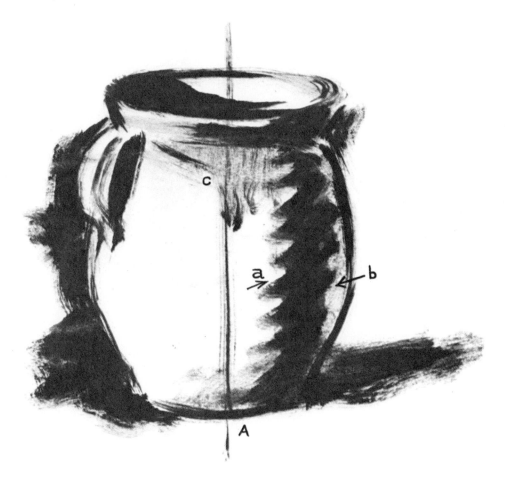

Notice that I have applied dark paint to the background adjoining the well lit area of the jug. Also, I have tried to form the three dimensional shape by showing the shadowed area on the jug and the reflected light, *b*, with the zig-zag strokes, *a*, and I have tried to sketch in the shading and blending.

Finally, you can see how in this first stage very light tones can be painted with an almost dry brush without any essence of turpentine. This produces light tints with dragged brushwork as shown at *c*.

First stage

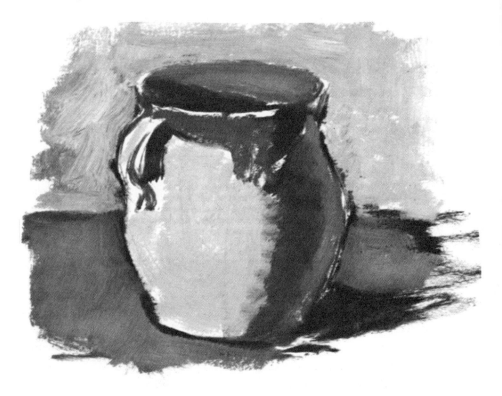

FIRST STAGE

You must work out the values, fix the general tones and rapidly color the entire picture to eliminate the stridency of the white and dark, and to produce a result which is closer to the tonality of the final stage.

Three, or at most four, tones will be needed for this first step toward the final values. Using the bright No. 8 brush almost throughout, begin with the light gray of the background and then go

on to the other light color on the jug itself, the highlight. Now deal with the shadowed area of the jug and the dark sections along the edges and the interior using the flat No. 4 brush. Then quickly paint the dark tones of the table.

You should not be too concerned with the actual shape of the drawing but neither must you paint so casually as to lose the structure and the initial composition.

SECOND STAGE

Now take a rest. Relax! Ideally, you should wait long enough until you can come back to your painting with a fresh mind. Then you can see what you have to do and how you must do it. After your picture has dried a little, it will give you a firmer surface for *repainting by drawing.* But this is just practice, so let's imagine you have now come back to your painting.

First deal with the jug itself. Restructure it by painting and drawing the forms and tones of the upper half: the edge of the neck, the interior, those dark areas around the neck, the handle and its shadow. Carefully study the somber tones and the simplified planes of the model shown in the illustration on page 56. There are three or four tones, no more. Now remember that going over the line is sometimes useful for outlining the areas of dark tone with lighter tones. There are several instances of this in the upper section of the jug.

When painting the curve along the upper edge, begin by tinting the entire strip with a dark color. Then go over the line, encroaching on the background so that you can outline it with the almost white-gray color of the background.

Using the same dark tone, paint the varnished patches of the shadowed area. Then, ignoring the final shape, go over the line so that you can outline it by superimposing the light tone of the jug. The same applies to the shadow cast by the handle. Do you see how the light paint climbs over the dark, bringing out the shape?

Use this method of superimposing light on dark on the nearest section of the top. A white strip is drawn freely with the flat No. 8 brush, moving from left to right, ending on the right with a flip of the brush which produces the shaded stroke.

Leave this section. Do not add the white highlights yet. These should be left until last when you are sure that nothing else needs to be retouched. Now work on the body of the jug, then the shadowed and the broad, well lit areas. Be careful here. Do not make the mistake of having an over-delicate finish with precise and smooth shading. It is easy to give way to the pleasure of working the brush to and fro, blending and reblending and ending up with a mechanical picture, cold and lifeless. Here again, paint boldly and rapidly, standing away from the picture. Don't worry too much about precision.

Now turn to the background. Here you can really enjoy yourself. Work with thick paint and a heavily loaded flat No. 8 brush.

Second stage

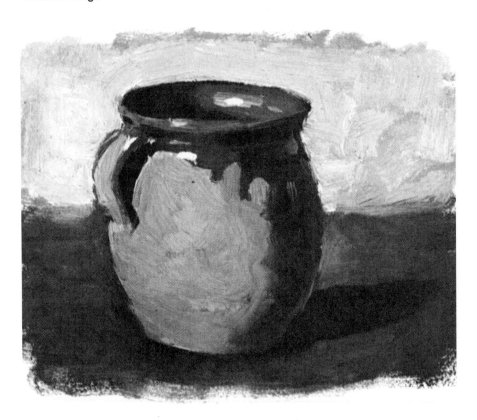

Finally, examine the illustration above and notice the direction of the brush strokes. Go ahead with your painting now. Add the highlights using your flat No. 4 brush. Good luck and enjoy yourself.

Practical Exercise

Let's continue to use burnt umber and white for practice, but this time we'll paint from nature. The subject is a still life.

You choose the items. Study and decide upon the *composition*, the way in which some objects are placed in relation to each other, as well as the viewpoint, lighting and framing.

There is only one condition: it must be simple. Arrange a few objects in the simplest way possible. You are not trying to paint a picture in the true sense of the word. This is practice, so choose a subject which enables you to paint and practice.

As an example, look at the subject I have chosen and painted for this exercise on page 62: two salad dressing cruets, a tomato and an onion. You can use the same subject or change the jars for a vase, a jug or a bottle. You can place vegetables or fruit in front or at the side.

But don't complicate matters by choosing objects with a difficult shape or by including too many items.

Choose simple lighting. The traditional front side or ordinary sidelight with only one angle, preferably daylight from a door or window, will work well. Make the arrangement similar to mine with the vegetables or fruit in the foreground and the object of your choice in the middle ground.

Finally, choose a frame in which you can paint the objects on a fairly large scale. Most beginners make the mistake of making the subject so small that it is lost in the center of the picture against an over-large background. Remember, the objects are the subject of your painting. Let them fill your space.

PREPARING THE SURFACE

Let's paint this on cardboard. The ordinary gray cardboard that comes in your shirts from the dry cleaners is fine.

You can paint directly on this type of cardboard without any preparation. I know many artists who do. It has one drawback or advantage, depending on you look at it. The spongy fiber quickly absorbs

the oil and essences in the paint so that it dries very rapidly and gives a completely matte finish.

But I prefer to paint on a surface that lets my paints dry a little more slowly, so I am going to prime the surface of the cardboard, following the directions on page 26.

This completes the preparation of the surface. You should now wait at least two days for the two washes to dry completely.

After two days the surface will look matte. The priming or coats of paint will reduce the cardboard's absorption capacity, enabling you to paint under the best possible conditions.

You can of course do this exercise on prepared cardboard or fabric which is available in the art supply shops. There is no special reason why you need prepare your own cardboard, but at least now you know how.

PLACING THE SUBJECT

The upper figure below shows how a subject can be placed in relation to yourself and the light. There should be about 7 to 10 feet between you and the subject, forming a triangle with the window or light so that it shines on the subject and the table or stool on which you are painting.

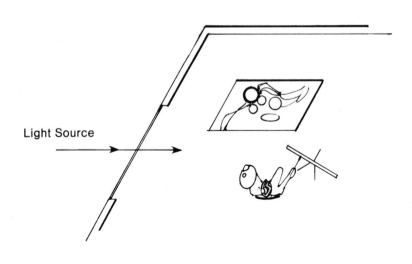

Light Source

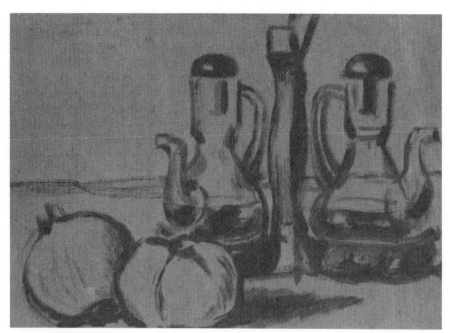

Composition

COMPOSITION

MATERIALS

Titanium white
Burnt umber
Flat No. 4 hog brush
Round No. 4 hog brush

Bright No. 8 hog brush
Sable No. 8 or 10 brush
Essence of turpentine
Rag

Begin by painting and drawing with the flat No. 4 brush and burnt umber diluted with a very small amount of essence of turpentine, trying to make a two-dimensional sketch of the model. Make this drawing directly on the prepared cardboard without any preliminary pencil sketch.

FIRST STAGE

Look at the upper figure on the next page. Since you are painting on a medium gray-sienna background, you can now fill in the large areas with a few quick strokes of lighter tones and begin to harmonize the tones and create contrasts.

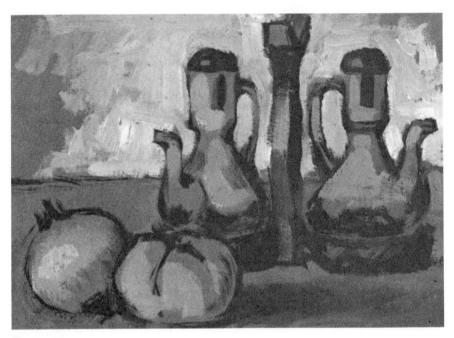

First stage

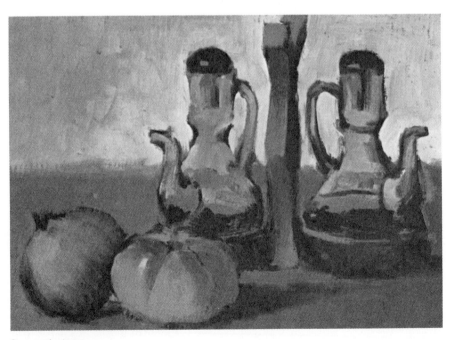

Second stage

Notice this effect on the upper figure on the opposite page. It is simply a matter of outlining the shapes and trying, incidentally, to obtain more or less the tones shown in the subject. From the very beginning, use plenty of thick covering paint with scarcely any essence of turpentine.

SECOND STAGE

First, balance the tones. Paint and repaint to blend the coloring. Do not bother too much about the exact shape of the objects, the precise outline and the position of a line. These will come later. At this stage, simply study the general tonality and structure and work freely all over the picture. Later you will paint over it and emphasize and adjust it to obtain the final result.

THIRD STAGE

This is the last step, and at this stage I think it is necessary to look rather than explain. Study the work done in the second stage in the figures on the facing page and the finished work on pages 62 and 63 so that you can understand what you have to do.

Try to distinguish the planes which form the shapes and try to paint them with as few strokes as possible. For instance, look at salad cruets where I have tried to simplify and synthesize the form and color of the object. To simplify in this way, squint your eyes and block out the lights and shadows and look at your subject. This will reduce them to flat shapes. Then shade with a mere touch of the brush wherever any extra touches are needed on your painting.

Finally paint all across the picture moving from one side to the other. Work from a distance, attentively, thoughtfully, but boldly. Remember to leave the highlights until last.

The following day you may want to add a few touches. Do this fearlessly. You can see that oil painting has the advantage that you can always work over it again, go back to it, especially when you are painting for practice with only two colors. When you paint with three colors, the primaries, which is the same as painting with every color, it is a different matter. But that belongs to the next chapter.

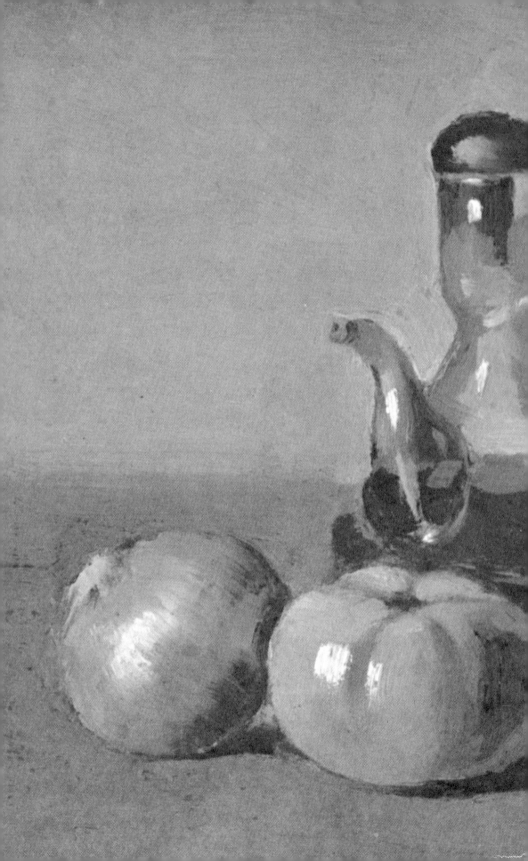

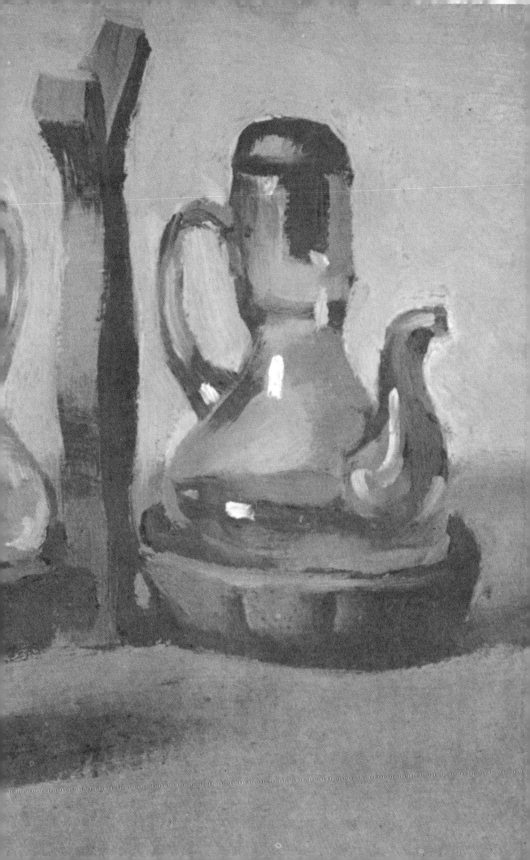

3 PAINTING WITH THREE COLORS

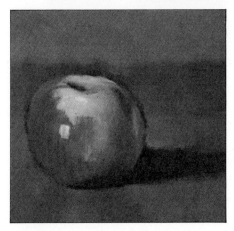

Mixing Primaries
Painting an Apple
Painting a Still Life
An Unexpected Exercise

These are the colors we will be working with in this chapter: white, blue, red and yellow. We say painting with three colors because white is technically not a color. Even though you will occasionally paint with it as you do the other colors, for highlights and white areas, it is used more often to increase the opacity of other colors.

In oil colors we will use:
Titanium white
Prussian blue
Alizarin crimson
Medium cadmium yellow

If you mix each of these three oil colors with a little white, you will obtain greenish blue, light alizarin crimson with a purple tinge, and a luminous, medium yellow.

This medium blue, alizarin crimson and yellow are the three *primary colors,* the three basic colors which, when mixed, give you the *secondary colors:* green, violet and orange. When you mix primaries with the secondaries, you get the *intermediate colors:* yellow-green, blue-green, blue-violet, red-violet, red-orange and yellow-orange. Every color in nature can be obtained by mixing the three primaries in various proportions, including black by mixing the three primaries in equal proportions.

Rubens painted with four or, at the most, five colors. Titian painted with an even smaller range and said, "It is possible to be a great painter using only three colors."

However, it is inconvenient to always paint with just the three primaries. For example, it is impractical to keep trying to mix ochre from blue, purple and yellow when ochre can be obtained ready for use from a tube.

Nevertheless, this exercise in making every color from the three primaries is extremely valuable training. It will give you a practical knowledge of mixing and obtaining tones, shades and colors. And it will help you to see and capture the color of your subject matter.

Every natural color always contains blue, red and yellow.

This applies to flesh-tints, the color of the earth, the blue sky, green leaves and red flowers. Each of these colors must use some measure of all three primaries. Look at your hand and notice its flesh color. Basically this color is composed of red, yellow and white, but if you want to try to match it without using blue you would simply obtain a light orange or light cream which does not correspond to the general color of your hand. If your skin is dark, you will need more blue; if it is light, less blue, but there will always be some blue, red and yellow present. A sky requires a little red and yellow to produce a deeper and more realistic blue. Red flowers contain yellow in their highlights and reflections, and there is blue in the shadowed areas and cast shadows.

The following exercises will help you to see this more clearly.

A BASIC PRACTICAL EXERCISE

Before discussing the materials and preparations, I must tell you that this exercise is one of the most important for learning to paint with oils. Better than any number of instructions, it will teach you how to mix colors and what amounts of blue, red and yellow are needed for any specific shade. It will also show you how one color influences another, and how to obtain such vague but common colors as the grays of a dawn, the siennas and golds of an autumn landscape, the blues, grays and purples of a background, interior or object in shadow. You will also learn how to use a wider range of colors in the right proportions to achieve the effects you want.

This exercise will also teach you that you must work with a clean palette and brushes to obtain clean colors. You will also gain practical experience with varying degrees of opacity, density and intensity of one color in comparison with others. You will learn to mix colors on the palette or directly over the area already painted, correcting a tone, repainting over another color and so on.

Let's begin.

Mixing The Three Primaries

In this exercise we will create 80 different colors using only the three primaries.

You can see these 80 colors on the following pages: they are numbered and arranged by tones and ranges. The color ranges used for painting can be divided into the *warm* and *cold* ranges. The warm colors contain red as the dominant basic color, while the cold colors are based on blue.

The color chart on the following pages distinguishes between warm and cold color ranges. In general, colors 1 to 40 are predominantly warm colors based on yellows, reds, carmines, ochres, siennas, green and even blues that have a reddish tinge. Colors 41-80 compose a cold range with greens, blues, purples, ochres and even siennas, all with a bluish tinge.

Pay special attention to this division into warm and cold when you start to paint. It is much easier to harmonize your colors if you stay within either the warm range or the cold range, rather than trying to use both.

MATERIALS

Titanium white
Prussian blue
Alizarin crimson
Medium cadmium yellow
Flat No. 8 hog brush
Round No. 4 hog brush

Bright No. 8 hog brush
Palette
Essence of turpentine
Oil jars or a small container
Thick Canson paper
Rags, pushpins, pencil

Mixing the three *primaries*, yellow, blue and red produces the three *secondaries*, green, violet and orange. If all the three primaries are mixed together, we obtain black as shown above. In the diagram below you can see that mixing a primary and a secondary will give you one of the six *intermediates*, yellow-green, blue-green, blue-violet, red-violet, red-orange and yellow-orange.

You need only three brushes because you should learn now how important it is to clean your brush very frequently.

PREPARATION

Pin a sheet of Canson paper on a piece of cardboard or wooden board which is set up in an upright position resting on a chair or easel. Arrange the colors on the palette in this order from left to right: blue, alizarin crimson, yellow and white. Please follow the order I have set out. Now we are ready to experiment with mixing colors.

The Range of Warm Colors

1 2 3

1. Lemon Yellow—Simply use white and yellow. With the flat No. 8 brush, place some white in the center of the palette and add a tiny amount of essence of turpentine to make a paste. Then take a little yellow and mix it with the white until you obtain a uniform color. Do not add too much yellow at the start. Adding more yellow to intensify the mixture is easier than adding more white to weaken it.

2. Medium Cadmium Yellow—Use the yellow as it comes from the tube. But wait a moment. You must clean your brush because this yellow has to be placed in the center of the palette without any trace of white, so that the paste produced is pure yellow. Otherwise you will not obtain a pure, strong cadmium yellow.

3. Light Orange—Mix yellow and a very small amount of alizarin crimson. Notice how strong alizarin crimson is. Just a touch of it can tinge and change the yellow. Both alizarin crimson and Prussian blue are capable of tinting the whole mixture when mixed with light colors.

4. Dark Orange—Mix the same as in Number 3, but with slightly more alizarin crimson. This can be added without cleaning your brush.

4 5 6

5. Vermilion—Add a little more alizarin crimson to the dark orange. Notice, however, that we cannot produce a pure luminous vermilion. This shows why it is perfectly justifiable to use other colors in addition to the three primaries when you are painting under normal circumstances.

6. Carmine—Add alizarin crimson to the vermilion.

7 8 9

7. Dark Carmine—Alizarin crimson straight from the tube without any yellow.

8. Very Dark Carmine—Mix alizarin crimson and a very little blue.

9. Light Flesh-Tint—Mix a lot of white, a little yellow and very little alizarin crimson. This is the typical flesh-tint used to represent very luminous small areas. Remember that we have just painted a very dark carmine. You must clean your brush thoroughly with essence of turpentine and with soap and water before you start on this color.

CLEAN BRUSHES, CLEAN PALETTE, CLEAN COLORS

The exercise so far has brought out some points which are really important for successful oil painting.

First of all: clean brushes, clean palette, clean colors. This is directly connected with what I call *the pitfall of the grays*. A beginner will often find that his colors and his *palette* become gray and lose their purity and character. Consequently his pictures are also gray. This is usually caused by using too much black and white for darkening and lightening. To darken or lighten a color, we must remember the range of the spectrum, that is to say the regular order of colors as shown in the rainbow, and act accordingly. This is explained in greater detail in the volume in this series entitled *Color*.

The cleanliness of the paints, palette, and particularly your brushes also has a considerable influence when you are trying to obtain a specific color. If your materials are not clean, you are liable to produce a monotonous, uncontrasted range of colors with a marked grayish tinge.

Suppose, for instance, that you are painting a human face or body and require the light flesh-tint (Number 9) which is particularly suitable for highlights. Remember that no blue is used when mixing this color. To paint most of the face or body, you must work with darker flesh-tints which are based on ochres, reds or siennas, all of which contain some blue as well as yellow and red. All your brushes will be saturated with this range of flesh-tints containing blue. Then if you want to produce the luminous hue of this light flesh, you must thoroughly clean one of your brushes, take clean white, clean yellow and clean red or alizarin crimson, and mix them on a clean spot on your palette. You must take every precaution to prevent the colors on the other brushes, which contain blue, and the other mixtures on the palette, which also contain blue, from spoiling the brilliance of the light flesh-tint.

This rule must be obeyed with every color if you want to obtain accurate colors uninfluenced by the previous mixtures. If you do not clean carefully, the colors will not vibrate or stand out. Each time you mix they will become dirtier and closer to that mealy gray which can ruin your painting.

WHEN MIXING A COLOR ON YOUR PALETTE, STRENGTHEN THE TONE BY PROGRESSIVE STAGES

So as not to waste paint in these early exercises, use only a little paint and try to underplay the tone. For example, if you have to mix a rosy flesh-tint, start with white and very cautiously add alizarin crimson and yellow, darkening the mixture by progressive stages. Test it and strengthen it slowly until you have the proper shade.

This brings us to one of the special qualities of color. A color mixed on the palette can seem the identical to that in the model, but may turn out to be wrong when added to the picture. The surrounding shades influence each color and vice-versa. For instance, suppose you want to paint a red flower, such as a carnation, which is placed on a white table cloth beside a vase, as if it had fallen out. We can be sure that this red will not be the solid red as it comes from the tube. It will need a little yellow, white and blue to reproduce the real color of the flower. Now imagine you are mixing this color on a palette on which a sienna or a dirty brown background has been mixed. *Because of the slight contrast offered by this dark background*, you may well produce a red which is much darker than you need. This is a very common occurrence and the solution is to *test the color by putting a brush stroke on the appropriate spot in the actual picture.* This will tell you whether the color on your palette has to be lightened or darkened. Then you can mix and test again.

We shall now continue mixing colors in the warm range.

| 10 | 11 | 12 |

10. Luminous Flesh-Tint—Slightly darker than Number 9, this is produced by mixing white with more yellow and alizarin crimson but no blue.

11. Rosy Flesh-Tint—Same as before with more alizarin crimson than yellow but still no blue. Commonly used for painting cheeks, ears and hands.

12. Light Ochre—This is an ochre very close to a flesh-tint. It is mixed from white, alizarin crimson and yellow in very small amounts, with a touch of blue.

13 14 15

13. Reddish Ochre—Also one of the flesh-tints, mixed the same as the previous color, but with a little more alizarin crimson.

14. Light Sienna—Mix white, yellow, alizarin crimson and blue in that order, with more alizarin crimson and blue than Number 13.

15. Venetian Red—As before but with more alizarin crimson and less white. Before mixing this color, it would be best to clean your brush so that the clarity is not affected by the gray tint of the previous color.

16 17 18

16. Raw Umber—The same as before with more blue and yellow.

17. Light Yellow Ochre—Clean the brush thoroughly. Start by making a light lemon yellow from white and yellow. Then produce a light green by adding a touch of blue and a touch of alizarin crimson.

18. Yellow Ochre—As before but increase the amounts of yellow, alizarin crimson and blue.

19 20 21

19. Dark Ochre—Add more yellow, blue and alizarin crimson to Number 18 and there you are. Notice that white is not added here nor in 18.

20. Burnt Sienna—Add a little alizarin crimson to the previous color and that's it.

21. Gray Flesh-Tint—First wash the brush thoroughly and mix this color on a clean part of the palette. Mix white and a touch of alizarin crimson, giving a light rose. Then add a little yellow and a little blue. This color is very common for painting flesh.

22 23 24

22. Grayish Rose—Same as before with a little more alizarin crimson.

23. Light Violet—Add more alizarin crimson to the previous color.

24. Medium Violet—Add more alizarin crimson to the previous color but no white.

25. Light Green—First, mix white and yellow to produce a light lemon yellow. Then add a little blue to turn it green. Finally add a touch of alizarin crimson. Thoroughly wash your brush and palette to obtain clean colors.

25 26 27

26. Light Khaki—Add yellow to the previous color to give a warmer tint.

27. Light Terre-Verte—This is a kind of greenish khaki, a warm green with reddish tint. You obtain it by adding yellow, blue and alizarin crimson to the above, but no white.

28 29

30 31 32

28. Medium Terre-Verte—Mix as before but with more yellow, blue and alizarin crimson.

29. Violet Light Blue—Your brush must be thoroughly clean to produce this and the following colors. This is a warm blue with a tinge of carmine. It is mixed from white and a little blue with just a touch of alizarin crimson. There must be no yellow, of course.

30, 31, 32. Blues with a Reddish Tint—These blues are in the same range as Number 29 but with increasing strength. You have to add increasing amounts of blue and alizarin crimson, without any yellow.

33 34 35

36 37 38

39

33-39. The Range of Warm Grays—Grays with a reddish or ochre-sienna tint are called *warm grays*. It is not necessary to clean your brush and palette. You can even try to mix these grays from the odd colors left on your palette, because if all these are mixed together, they will probably produce gray. However, you may first obtain a

bluish neutral gray. In that case, you must clean your brush with your rag, take some white and obtain a light gray by mixing in a little of the colors left on the palette, adding yellow, alizarin crimson and blue. Then, to produce the following grays, you need simply add increasing amounts of each color.

Remember that the white must be gradually overcome to make the grays darker, as in Number 39, for example.

40

40. Warm Black—Clean the brush thoroughly and mix this color in a clean part of the palette. This and any other black must not have the least hint of white. First mix some blue with a small amount of alizarin crimson and even less yellow. You will then obtain a neutral black. Add as much yellow and alizarin crimson as you wish, producing a slightly reddish tint and a warm black.

The Range of Cold Colors

41 42 43

41-44. Cold Yellows and Flesh-Tints—Use a clean brush, some white paint, and add a little yellow and minute amounts of blue and alizarin crimson. Little yellow should be used or else the color will appear warm. The same applies to the alizarin crimson. This produces the range of cold flesh-tints which are very common in paintings of human faces and figures with a bluish tint.

44	45	46

45 and 46. Cold Ochres—The same mixture as for cold yellows, but with less white and more yellow, blue and alizarin crimson.

47	48	49

47. Neutral Gray—Without cleaning the brush, add a little more blue to the previous color and perhaps some yellow and alizarin crimson.

48. Dark Neutral Gray—A neutral gray with a very slight coldness is produced from Number 47 by adding a very little more blue.

49. Light Green—Begin with a lot of white, then add yellow and blue.

50	51	52

50. Bluish Light Green—As before but with more blue. Notice the mealy pastel effect caused by the large amount of white. Compare it with the next color where the green is cleaner and stronger because it has less white and more yellow.

51. Light Neutral Green—Clean your brush to remove the white left over from the previous color. Then mix blue and yellow and lighten it with white and yellow. This shows how you can brighten a color with yellow.

52. Medium Neutral Green—Same as before, with more white, yellow and blue.

53 54 55

53. Strong Green—Merely note that there is more yellow than in the previous color.

54. Dark Strong Green—Strengthen the previous color with blue and a little yellow.

55. Viridian—Clean your brush to remove any traces of white and mix a little yellow with a large amount of blue.

56 57 58

56. Greenish Black—Clean your brush again. Mix a lot of blue, a little yellow and a touch of alizarin crimson.

57. Very Light Prussian Blue—Your brush must be cleaned thoroughly with essence of turpentine and soap and water. You must

also work with a clean white and a pure blue, using a clean part of the palette. Mix a lot of white and a touch of blue.

58. Light Blue—As before, with a little more blue.

59 60 61

59. Sky Blue—As before, with more blue.

60. Light Cobalt Blue—Mix white, blue and a touch of alizarin crimson.

61. Medium Cobalt Blue—White, blue and extremely small amounts of yellow and alizarin crimson.

62 63 64

62. Medium Prussian Blue—Clean your brush. Mix white and Prussian blue and nothing else.

63. Grayish Blue—The same Prussian blue as before with a little alizarin crimson and a touch of yellow.

64. Blue-Black—This is almost Prussian blue as it comes out of the tube: you need add just a very little alizarin crimson. As always when producing a black, the brush must be clean.

65
66
67
68

65. Light Rose—Clean your brush thoroughly. Mix pure white and a touch of alizarin crimson.

66. Carmine-Rose—As before with a little more alizarin crimson.

67 and 68. Purple-Blues—White, alizarin crimson and a touch of blue.

69
70
71
72

69-72. Violets—Clean the brush and mix these purplish blues from white, blue and a touch of alizarin crimson. Gradually increase the amounts of the last two to strengthen the tone.

73-79. Cold Grays—You already know how to obtain a gray. First mix the colors left on the palette, then add white and the color or colors required to produce, in this case, a range of grays with a bluish tinge. Or you can mix gray from the three primary colors.

80. Blue-Black—This is virtually the same as Number 64. Again, wash your brush first.

Painting With The Primaries

We are now going to apply the instructions for mixing colors from the previous exercise to a specific subject and put your knowledge of mixing and cleaning into practice.

At first paint only one simple object which entails no problems of drawing or composition. Experiment with the color factor and the technique of oil painting. Try this exercise with an apple, a peach, a pear or any spherical fruit which has an uncomplicated form but offers the widest possible range of colors. We are now approaching a fairly advanced stage.

COMPOSITION

MATERIALS

Titanium white	Bright No. 8 hog brush
Prussian blue	Palette
Alizarin crimson	Essence of turpentine
Medium cadmium yellow	Oil jars or a small container
Flat No. 8 hog brush	Thick Canson paper
Round No. 4 hog brush	Rags, pushpins

I shall use an apple for my demonstration. Using a flat No. 8 brush, mix a very dark gray with a reddish tinge and dilute with essence of turpentine. Very lightly paint the circumference or shape of the apple and the shadow it casts upon the table. Lightly indicate the edge of the table against the background with a horizontal line. Using the same color but slightly darker, paint a few contrasting patches around the apple as you did when painting the cube using burnt umber.

Quickly paint the two background colors: the dark khaki of the wall and the dark sienna of the table. These are similar to samples Number 28 on page 74 and 16 or 20 on pages 72 and 73.

Thoroughly clean your brushes and start on the apple by applying a brilliant yellow with a slight greenish tint mixed from white, yellow and a little blue with your bright No. 8 brush. Not too much blue though; the yellow should remain dominant. Let this spread into the shadowed areas, but do not allow it to reach the right edge of the fruit. Also apply it to the reddish area which now has that orange shade.

Clean your brush and make a bluish gray for the edge of the shadow, mixing it with the previous yellow which is still wet, and a reddish carmine. Work upwards from the lower left edge until it mixes with the yellow to produce that orange-red. By mixing the orange with the bluish gray, still using the same brush along the base of the apple, you will obtain that orange-gray which completes the basic shape and coloring of the fruit. A final touch of the bluish gray on the top produces the hollow of the stem. Clean your brushes with your rag.

FIRST STAGE

Repaint the table and background, trying to adjust the shades with a thicker layer of paint than before. You will be able to go back again to give the final touches to these tones and colors.

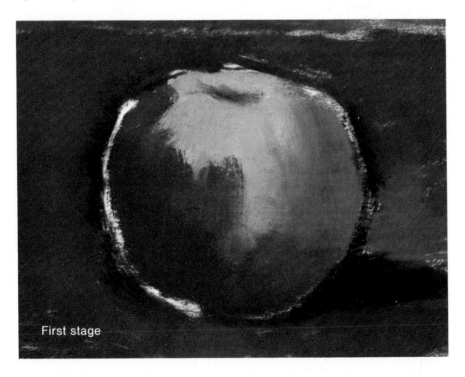

First stage

But wait a moment. A background is not merely a splash of even color. In the model it shows slight variations of shade. So you must try to capture these slight differences to give your picture a richer coloring. On the left of the khaki background, for instance, you can add a little yellow, and on the right, a little more blue. The more distant area of the table has more blue in it than the foreground, which becomes lighter on the right and particularly behind the apple, emphasizing the shape and volume of the fruit.

Remember that the two colors of the background and table must blend where they meet and not show a clear edge. For example, the two colors spread into each other's areas behind and above the apple, and a brush stroke of the khaki background enters the dark sienna of the table.

Go back to the apple. Begin with that luminous lemonish yellow, painting not only the actual yellow area but also the orange, green and gray parts of the area in shadow. Use thicker paint where the yellow stands alone and less paint in the areas which must be a reddish orange or bluish green at the end.

Thoroughly clean your brushes, except the bright No. 8 for the yellow. Mix a strong red from alizarin crimson and yellow. Do not use white now. Start to paint the red areas, working upward with vertical strokes which follow and model the shape as shown in the example opposite.

When you reach the yellow areas, where you will almost accidentally produce an orange color, paint with downward strokes, outlining the solid patches of orange near the white highlight.

By mixing blue with this orange, you will obtain the reddish sienna tones which give the form of the apple in the shadowed areas at its base.

A rather dirty green with a slight amount of alizarin crimson will do for painting the shadow. While the paint is still wet, you can then lighten this color and add the reflected light contained in this shadow.

Try to mix a black with a red tinge for painting the thin shadow along the base of the apple using the edge of your flat No. 8 brush. The black should turn into blue as you move away from the fruit into the cast shadow.

When you want to blend colors, remember that you can do this by thoroughly cleaning your No. 8 brush and rubbing the newly painted areas with it.

SECOND STAGE

Finally, make every effort to synthesize, expressing yourself with as few brush strokes as possible, working out their extent, form and aim to obtain a spontaneous picture without *overworking* it by mixing and remixing, painting and repainting to give a hesitant, heavy and dirty finish.

Leave the highlight until last. Thoroughly clean your brush and mix white with a slight yellow tint. Apply it simply by *laying on* top of the previous coats. Don't rub it in.

Easy, wasn't it? Of course, you do not need much time to paint a fruit such as this. One hour at the most during which you paint almost non-stop, trying to apply the tones and colors directly without having to change them later. This is called *direct painting* and we discuss it more thoroughly on page 112.

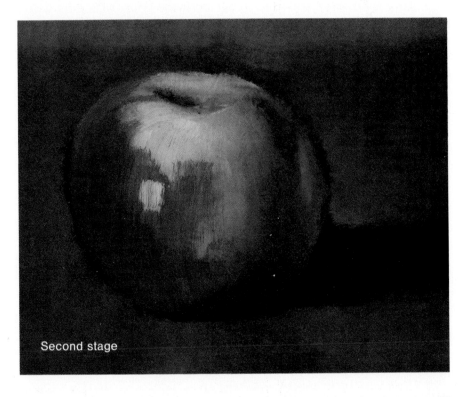

Second stage

Painting A Still Life With Three Colors And White

To complete this first lesson with oil colors, we are now going to paint a still life from nature using only the three oil primaries, Prussian blue, alizarin crimson and cadmium yellow, together with white to produce every color. This is a challenge, because I want you to find out how capable you are of *seeing and mixing colors*, drawing and painting at the same time, and applying the instructions given in the previous exercises.

Choose a simple subject containing only a few items which have simple forms. We are more concerned with learning how to see and interpret a color on the basis of the three primaries, than with painting a picture.

As an example, I have painted a subject to experiment with the three primary colors. I have composed the subject as simply as possible: a bottle, a coffee pot and a china cup and saucer on a dark background. There are just these four items.

Of course, your still life need not be composed of these items. You can use other objects such as earthenware pots or cooking utensils, cutlery and tableware, food or fruits, as long as they provide a range of color. Follow your own taste.

COMPOSITION

MATERIALS

Titanium white	Bright No. 8 hog brush
Prussian blue	Sable No. 2 brush
Alizarin crimson	Palette
Medium cadmium yellow	Essence of turpentine
Flat No. 4 hog brush	Oil jars or a small container
Flat No. 8 hog brush	Thick Canson paper
Round No. 2 hog brush	Rags, pushpins

Start with a sheet of Canson paper twice the size shown here. Sketch in the objects you have selected, showing their position and their basic forms. My sketch was done with a flat No. 4 brush and paint leftover from the previous exercise diluted with essence of turpentine. I drew it very quickly.

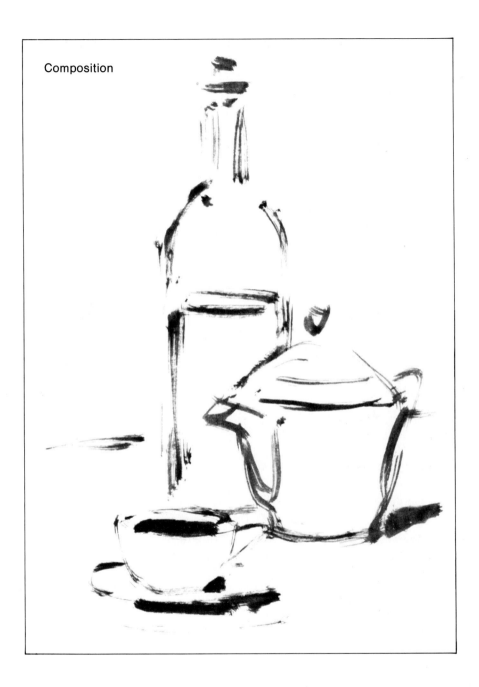

Composition

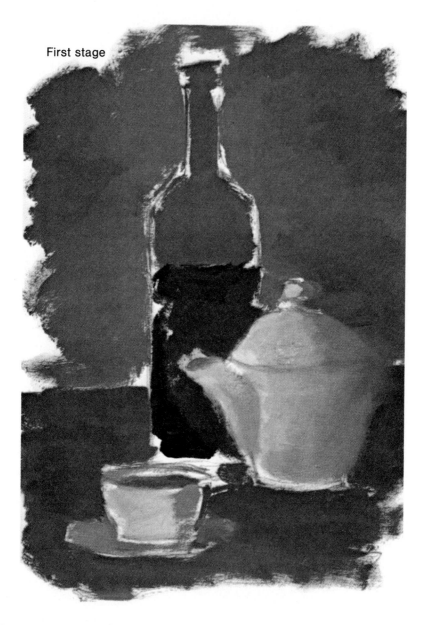

First stage

FIRST STAGE

This stage was painted in less than fifteen minutes. It was a matter of filling in the space rapidly with rather thin paint, while still trying to capture the coloring and the general tones of the subject.

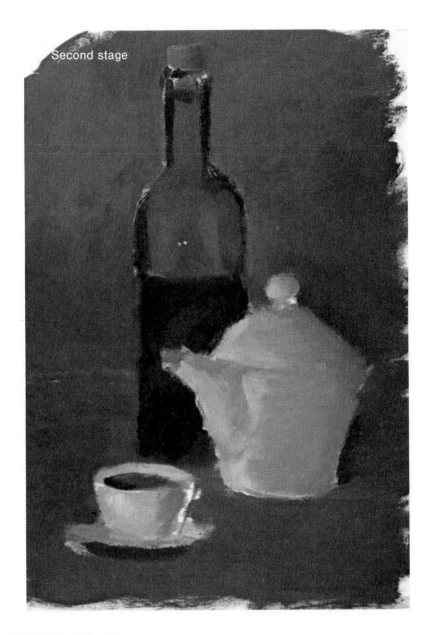

SECOND STAGE

Now I can pay more attention to the colors, especially the background and the bottle, while I try to fix the final general values of the subject. This stage already shows an awareness of the harmonization based on grays and blues. It also shows the composition, leaving the bottle in shadow and bringing out the tonal values of the coffee pot and the cup and saucer.

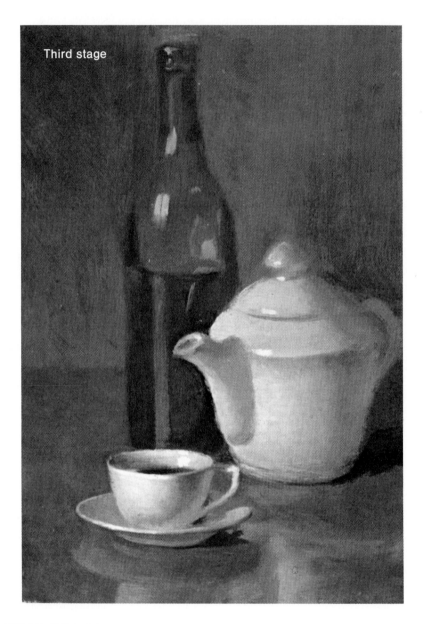

Third stage

THIRD STAGE

This merely shows how I built up and gave the objects their final form, working on the basis of the previous coloring and harmonization. Notice the following important details in this stage in the illustration above.

The outlines of the more distant and shadowed areas are more vague, as in the shape of the bottle whose central section blends strongly with the background or the shadowed outline of the coffee pot which is completely merged. On the other hand, notice that this atmospheric feeling of vagueness is not found in the shadowed edge of the cup which is thus brought more into the foreground.

The highlights on the bottle appear to be white but are in fact a light gray with a greenish blue tinge. Notice too the imprecision of form, color and volume in the cork. Both these points, the highlights and the cork, were weakened intentionally to prevent stealing attention from the coffee pot and the cup and saucer.

The coffee pot, cup and saucer are made of white china. When they were placed on the table, I could see the illuminated area as a dazzling white, vivid and brilliant. However, I did not make the mistake of painting these brilliant areas with pure white because I would not have been able to use that color later to show the real highlights, those small flashes of light on the edge of the cup, saucer and the lid of the pot.

Notice that the shadows contain a range of blue, but these blues contain reflections and mixtures of yellow, green and red.

AN UNEXPECTED EXERCISE

When I looked at this study of the coffee pot and cup, the painting seemed so blue, I wondered if you would be able to see all three primaries.

This worried me, but suddenly I had an idea. There was enough blue, alizarin crimson and yellow left on my palette, so I added some white and took the studio mirror and placed it in front of me.

I pinned a sheet of watercolor paper to my board and, without even a preliminary sketch, began to paint my self-portrait as reflected in the mirror using a tint resembling shadowed flesh. The result is on the next page.

Please study the colors in this rapid picture and try to find them in the 80 sample colors you already painted. Almost every color in

this study is there in your exercise. Some of the shades are not exactly identical, but you can see how you could obtain them by adding or subtracting blue, alizarin crimson or yellow.

There is no reason why you should not try this yourself. You may not think you have enough experience, but that is gained by practice, by painting. You only need a few more instructions on technique. So why not get out your materials and paint?

HOW TO PAINT WITH OILS 4

Choosing a Subject
Composing the Subject
Interpretation
Common Oil Techniques

You have finished practicing and now you are going to paint a picture in oils with no restrictions other than those imposed by the medium itself.

This exercise will consist of creating a finished painting on canvas, using every color commonly employed by professional artists. This will broaden your practical and theoretical knowledge and let you examine all the possibilities of expression, technique and skill.

The Subject: Selection And Composition

Artistic creation is not a spontaneous function. It is wrong and naive to imagine, as a layman is apt to do, that the artist is a privileged

person driven by inspiration and expending hardly any of his own powers. Inspiration certainly does not fall from the sky like lightning. You have to encourage it by deliberation, sketches and hard work; by an intellectual process which includes observation, imagination, knowledge and experience.

A subject is usually suggested by something you have seen: a combination of forms and colors, a special effect of light and shade, of contrast and color. This first vision may well come when you least expect it: at a bend in the road, when entering a room or looking at a child. But it cannot be fully seen and appreciated unless you have a conscious desire to observe, see and discover.

The first requirement for finding and choosing a subject is to cultivate our powers of observation in order to see the world around us. When you go outdoors, stop looking at things subjectively. Forget yourself, your worries and problems. Instead, look at the people, the doors and windows of the houses, the perspective of the streets and fields, the effects of light and shade on a sunny or cloudy day. Teach yourself the habit of noticing shapes and the colors of your surroundings.

A subject for a picture and the method of painting can also originate from something which the artist has previously imagined: a figure study, for instance, or a still life entitled *Small Game*, or a mural on *Labor*. The objects, composition, colors, contrast, style and so on can be imagined and even sketched out without having a model in front of you. Nevertheless, when creating an imagined subject such as this, the artist will make use of visual memories, the images, forms and colors that he has seen. In fact, his spirit of observation is continually contributing and linking new ideas.

Indeed, the subject ceases to be a vague concept and becomes reality when the artist employs his knowledge and experience. For instance, if he is planning a still life entitled *Small Game*, his knowledge and experience will enable him to visualize the elements of the picture: the light, the dominant color and the general composition.

Needless to say, these qualities, observation, imagination and experience, cannot be acquired overnight. They are produced by years of work and many successes and failures. So what can a beginner with virtually no experience do when it comes to choosing and composing a subject? Examine what the great artists of the past have

done. Study and observe, starting with the pictures in museums or in artbooks. Assimilate, adapt and even *copy*. Remember, these great artists did the same when they were students. Originality, creative powers and artistic temperament will come in their own good time. After copying and adapting ideas, colors and composition, you will feel a natural need to change. You will discover and formulate alterations which, as the number of your pictures increases, will lead you to find your own personal style.

CHOOSING AND COMPOSING A SUBJECT

Here in my studio I am going to paint a picture to help you begin to study composition. This will be a still life. Yes, another still life. This is not because I am addicted to still lifes. I actually like landscapes better. But you will appreciate that a still life is the most suitable subject for beginners. It enables one to start from scratch, choosing, arranging and composing the subject with complete freedom to explore the possibilities and to study the colors, techniques and handling at one's leisure.

I bought a rose this morning while thinking about the picture. And I found a death mask of Beethoven which will also be useful.

I have been wanting to paint this subject for some time now: a vase with a rose, a sheet of music and Beethoven's death mask. It came to me in a flash one day at home when my small daughter was practicing *For Elise* by Beethoven, that simple piece which every beginning pianist learns. On top of the piano were three or four roses in a jar. I visualized the death mask on the wall behind the roses. I thought of it as *Homage to Beethoven* or some such title.

Yesterday afternoon I tried to formulate the subject with a couple of rough pencil sketches. In the first I tried to recapture the image I saw that day over the piano with the light entering through half closed shutters. But it was not right. Although I had always visualized the picture like that, when I came to transform it into a sketch, I found that the viewpoint and light were unsuitable.

I then visualized a front view with the light entering from the front and side and drew the second sketch.

It seems better, doesn't it? I think the viewpoint is right with Beethoven's head at eye level and the rose just below and in front of

it. But the direction of the light bothers me. Yesterday, when I finished this sketch, I felt that it could be improved with more side lighting, so that Beethoven's face is half in shadow and half in light.

Let's see how it came out in practice.

First, I placed a rather low table against the wall. I intend to paint while seated. On the wall above the table, I hung the death mask. I put a vase containing the rose on the table and the rolled up sheet of music behind the vase as shown on page 98. I adjusted the rose until I found the best position. Then I sat about eight feet from the subject. This was the right distance for this subject, but, of course, this distance will not work for all subjects.

HOW FAR FROM THE SUBJECT?

There is no fixed distance. It always depends on the size of the subject. The smaller the subject is, the closer you should be and vice versa. You should be able to see the entire subject with one glance all the time you are working. If this subject included the piano with someone playing it, I should have to place myself at least five or six yards away from it.

FIRST ATTEMPT AT COMPOSING THE SUBJECT

The upper left photo on page 98 shows my first attempt at composing my subject. The first point that comes to mind is that the mask is smaller here than in the sketch I drew yesterday. I did visualize it as being larger in relation to the rose, but we can solve this problem later by reducing or enlarging the size while painting. At this point we shall just consider the arrangement and composition of the objects.

What about the light? It falls very well on the rose and the head, as you can see. I was right to *split* the mask. This gives more emphasis and, incidentally, makes the whole form simpler, less conspicuous and fixes it more firmly in the middle distance so that the rose stands out in the foreground. This leads us to one of the basic rules of composition. *Every picture must contain a strong center of interest or principal feature which stands out in relation to all the other objects.*

We must ask ourselves what we are intending to paint in this picture. Which of these items, the head or the rose, best expresses and synthesizes the idea of homage. I choose the rose. So the rose is to be the center of interest in this picture. Beethoven's mask will also be included, but as something imprecise with little contrast.

In view of this, I feel that this first attempt is not satisfactory. It provides too much variety and lacks unity. As you know, the first and most important rule of composition tells us to look for *variety within the context of unity.*

This rule is not obeyed in this composition. Look at it. The head is too distant from the vase and rose, requiring a large picture which reduces the importance of the elements and scatters them. The mask is isolated, forming a center of interest by itself, distracting and reducing the attention which should be focused on the rose.

A COMMON MISTAKE

In my years as a teacher I have corrected hundreds of drawings and paintings whose main fault was to reduce and isolate the various objects in the subject.

There were pictures whose elements seemed to be scattered without any connection between them, so that each formed its own center of interest and completely destroyed the unity of the work. Do

not make this elementary mistake. The subject must be arranged and framed so that the objects occupy a large part of the picture. At the same time, they must not be lost against a wide background. One way to do this is to place some forms in front of others, making a series of planes which reinforce the general unity.

SECOND ATTEMPT

It is obvious what must be done. The mask must be lowered closer to the rose. This is shown in the upper right photo on the facing page.

A perfect solution. Now we can begin to paint.

But wait a moment. Don't be satisfied too quickly. Try every possibility. A good professional does not accept the first idea even if it is satisfactory. What if we make the subject richer by adding some more objects?

THIRD ATTEMPT

For instance, add some books as in the lower left photo. Books, music and Beethoven are all linked thematically. Let's see.

No. You can see what happens. The shape and tone of the books placed on the left disrupt and destroy the main feature: the rose. We lose sight of its leaves and the pattern they formed when set against the bare wall. Let's try the other side.

FOURTH ATTEMPT

Look at the photo on the lower right. That's better. The shadow of the books on the wall forms a dark background that highlights the rose. But something is still wrong.

Those books! Their shapes are just not right. The upright backs and the light color of the first one, the thickest, doesn't work. By adding the books we have simply called attention to other shapes in composition, to the detriment of the center of interest, the rose.

I'll tell you what to do. Why not try to increase the impact of the center of interest by making it more important? Perhaps using a jar instead of a glass vase will help. Or perhaps by adding another flower.

FIFTH ATTEMPT

The upper left photo on the facing page shows my next attempt. It is certainly a radical change, but I think we are on the right track. The bud and the rose now dominate the scene and play a larger part than before. The small copper jar provides a pleasant note of color and helps to force the flowers into the foreground by its tone, form and color.

I have raised the mask in an attempt to form an L-shape with the rose forming the vertical stroke of the L on the left, and the sheet of music and the table as the horizontal stroke.

But this L-shape is not successful because it overloads the left side.

SIXTH ATTEMPT

For my next try, shown in the upper right photo, I moved the table to the left and placed the rose in the center. In the last analysis, the rose is the star of the picture. I think that when it comes down to it, the center is where it should be. I have also moved the sheet of music. I have placed the largest and lightest book behind the stem of the bud so that it becomes more prominent. The dark shape of the leaves and the stem stand out against the light color of the book.

SEVENTH ATTEMPT

It is possible to improve it even further by lowering the mask. This reduces the size of the picture, enlarges the objects in it and gives it more unity, as shown in the lower left photo.

EIGHTH ATTEMPT

I changed my mind again. I removed the books for a moment in order to see whether they were in the way and, as you can see at the lower right, I realized that without them the leaves and stem of the bud become even more prominent and are brought farther into the foreground.

NINTH ATTEMPT

With the books gone, see what we have in the upper left photo on the facing page. Let's go back to the beginning, but with a better idea of what we want. Do you see? With the flowers in the center of the picture and the mask behind. But wait! The leaves look like they are tickling Beethoven's nose. That must be fixed.

TENTH ATTEMPT

I raise the mask and move the branch to the left, but the subject is becoming scattered. The space on the right is unsatisfactory and, moreover, the leaves are now touching Beethoven's chin as shown in the upper right photo.

I don't want to lose the contrast between the bud and the shadow cast by the mask. This emphasizes the shape of the bud and gives it prominence because the illuminated shape is set against a shadowed background.

One thing has been improved. The position of the leaves now form a pleasing pattern which I intend to keep.

ELEVENTH ATTEMPT

I can still improve it. Bring the mask down behind the rose. Move the sheet of music more to the right in order to justify the space there, and we have the arrangement in the lower left photo.

FINAL COMPOSITION

At last, we have the arrangement shown at the lower right. This is the most successful way of relating the objects. In other words, this is the best composition.

As you have seen, a composition cannot be decided upon in a matter of minutes. It has to be studied thoroughly. Every possibility should be tried in order to produce the best result. Test and retest time and again. This is the lesson which I hope you will keep in mind in your future work.

Interpretation

The artist is now sitting or standing in front of the subject with the easel and canvas before him. The palette, paints and brushes are waiting within easy reach.

He takes a charcoal pencil, raises his arm, looks at the subject. It seems as if he is going to draw but no: without taking his eyes from the subject, he lowers his hand, puts down the charcoal, sits back in his chair, still examining his subject. Five minutes pass. Ten minutes. His gaze is still fixed attentively on the subject, following its forms, comparing spaces, colors and volumes.

Then, more relaxed, he begins to draw with a sure hand.

That is more or less what happens. In those minutes before he begins to paint, the artist *pauses to study the model.* He looks at it critically, examines the best way of interpreting it and decides what he is going to do and how he is going to do it. You must do this yourself when you paint: pause to study, calculate and decide.

Let's say that I am going to paint and have stopped to study and work out what I am going to do. Imagine that I am thinking aloud.

"The jar is big. Too much jar for so few flowers: I'll paint it smaller. The head, the rose, head, rose; yes, the head is small. I'll paint it larger. And, of course! Why not cut it short at the forehead? That's it! I can concentrate the picture more, increasing and bringing out the center of interest, the rose. I'll also lower the bud by shortening the stem down to the level of the chin. What about colors? A creamy yellow as a dominant, with siennas, reds and pinks. But, I'm not so sure. Let's try it anyhow. I pick up the charcoal and face the canvas. Here, in the center, I position the rose. The head up to here..."

I start to draw.

THE FIRST PHASE: DRAWING OR CONSTRUCTING

Some time ago there was a lot of argument about how to begin a painting. Some claimed that it is best to draw and construct the model

first with a charcoal pencil or a brush and paint. Others said it is better to paint directly on the clean canvas without any preliminary sketch.

The Renaissance chronicler, Vasari, tells us that the great Venetian painter, Titian "employed colors immediately without any preliminary drawing." Titian himself said that this "was the real and best way of working and was true drawing," meaning that he drew as he painted.

At the same time and in the same place, Michelangelo slyly commented about Titian's method, saying, "It is a pity that in Venice they do not begin by learning to draw properly."

Michelangelo, Rubens, David, Degas and Dali, to mention only a few masters, were addicted to constructing and drawing before they started to paint. Velazquez, on the other hand, said that "he did not prepare his pictures and sometimes did not even draw them." He worked *alla prima*, starting on the empty canvas immediately with a brush. Sorolla considered that "a brush with thin oil paint" such as you have been using in the previous exercises "is sufficient for indicating the proportions and placing of the objects on the canvas." Sorolla often started on a work without any preliminary drawings and then began to "daub" the canvas, covering it very quickly.

I feel that no matter which technique they preferred, everyone would agree with the following rule: *A painter does not see the shape first and then the color. He sees the colors in conjunction with the form, and the colored forms as a natural combination.*

This is the logical answer and I think that it would be accepted by any artist, whether he draws or paints directly or constructs the model in advance, putting in as much detail as he wishes.

In the case of a painter without much experience, I am convinced it is best to draw first and construct the basic picture before beginning to paint. In my years as an art instructor I have found over and over again that many pupils' paintings are ruined because the drawing is not given sufficient attention. I have also found that, despite their eager desire to learn, many beginning students are unable to control their impatience and irresistible desire to see the picture finished. This is bound to lead to failure because of their haste and lack of preliminary study.

If you are already able to frame, draw, and work out dimensions and proportions with accuracy, you can paint directly without any preparation. You can simply draw a few lines to fix the positions, dimensions and proportions of the objects in the model. On the other hand, if you are aware that drawing is your weak point, then you should conscientiously work on the construction, bearing in mind that it is the final result that really counts. Nobody asks *how a picture has been made.* People look at and admire *what has been made.*

On the next two pages you can see our picture. First it was constructed with a few simple charcoal lines that sketched in the basic shapes of the objects within the framework of a preliminary drawing. This fixes the frame, position, proportions and the dimensions of each object. From this you can begin to paint immediately. The version on page 108 shows the same drawing elaborated almost to the final stage: a finished charcoal drawing in which I have tried to give values to the model and assess the general tone effect.

Choose your own system in keeping with your abilities.

METHODS FOR DRAWING OR CONSTRUCTING

Whatever surface you use for painting, canvas, paper, cardboard or wood, the methods and media commonly employed for drawing the model are as follows:

BRUSH DRAWING WITH FLUID OIL PAINT

You already know this method because you employed it in the previous exercises. Let me add that a drawing of this type may consist of a few brush strokes for framing and placing the model, or it may be a finished drawing which even examines the effects of light and shade. In either case, it is usual to work with one color which is related to the general tones of the subject. Or you can use a medium gray which is the most neutral color. Rubens employed this method, painting the values with a dark ochre in some areas, and a lighter ochre in others. This provided an excellent tone structure over which he could paint the flesh-tints of his figures. The method is still used by some contemporary artists.

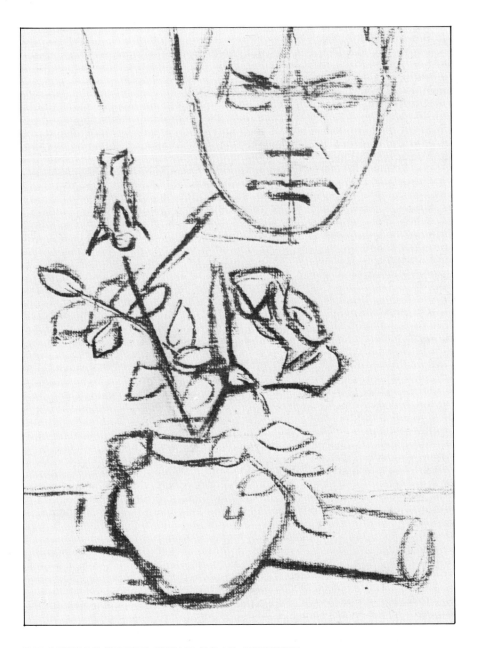

DRAWING WITH CHARCOAL PENCIL

This is the most common medium and is considered to be the classic method for drawing on canvas. The rough texture of the canvas enables the charcoal pencil to produce lines with astonishing ease. It also makes it possible to soften the lines quickly with your finger, which produces a very artistic effect. Also, because of the instability

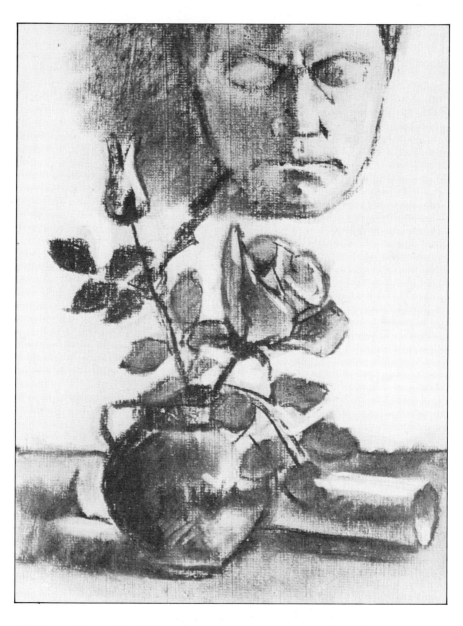

of charcoal pencils, it is easy to use an eraser to form light outlines and put in highlights. Notice the touches of an eraser in the rose, vase and sheet of music.

As well as being unstable, the charcoal pencil does not adhere completely to the canvas. It turns into minute particles of powder which barely manage to stick in the interstices of the canvas. Obviously it is not advisable to apply oils over such a drawing because

this may well make the colors dirty, especially white and the light colors. After you have studied the construction and values of your composition, you can wipe the canvas with a clean rag to remove the loose powder. This will almost completely wipe out the drawing and leave only a faint trace which is, however, quite enough for painting.

But why make a drawing and work out a construction with all the lights and shades, tones and contrasts, if only a faint trace of it is left after being wiped with the rag? You do this to make sure, to test and to fix the forms in your mind, to provide a memory which you can use for painting, when you draw with colors, tones and patches of paint. The preliminary drawing gives you a better chance for success.

It is not advisable to draw with a lead pencil and then paint over it in oils, because the graphite in the pencil can darken and stain the paint as it is drying. For the same reason, you should not use a colored pencil.

DRAWING IN RED CHALK

Red chalk with its reddish sienna color has also been used by many artists, especially in the past. It can be very useful in figure studies and portraits. Draw the lines with the chalk and then soften them with your finger. When the drawing is finished, it should be rubbed lightly with a clean rag to remove any loose chalk dust.

BEGINNING

Most of the old masters, such as Titian, Leonardo, Rubens, Velazquez and Rembrandt, started their figure studies by first painting the areas in shadow, implying that they were concerned about the three-dimensional form, as well as the color. Chardin, one of the most famous painters of the 18th century, first painted the dark areas by applying a thin coat of paint. Renoir used the same method but did not make it an absolute rule. In his portraits and figures he usually began with diluted paint and just a trace of color, painting the dark shadows. Then he went over it thoroughly with more color.

After drawing a very quick sketch, Cezanne sometimes painted from the edge of the picture toward the figure whose details he left until last. Strange as this method may seem, it does follow the rule of first filling in the background, that is to say, the largest area.

Remember that the old masters almost always painted over a *colored drawing*. That is a drawing painted with oils of one or two colors which were compatible with the dominant color planned for the picture. Veronese, for instance, used a greenish ochre color. Some masters painted on colored canvases. Velazquez used canvas primed with a reddish sienna. This is why the idea of first painting the darker areas was widespread. The artist had to cover the color of the primer. The method is still valid today, especially for figures and portraits.

However, in modern painting, we usually paint on white canvas with very luminous paints. We are more concerned with color contrasts, and the painter's first problem is to eliminate the white of the canvas so he can avoid mistakes in relation to his contrasts and colors.

When we paint a dark color over a white background, the color appears to be darker than when we see it surrounded by other tones and colors. For instance, painting a red flower on a white background, you can use a very bright rose color but not a strong red to give the impression of the real color. If we then paint the background black, the flower will appear pale red, not bright. It is just as if we have really lowered the intensity of the red flower. This is called the *law of simultaneous contrasts*.

On the other hand, if we allow for the *law of complementary colors*, a white background will produce a green tint in the red of the flower and around the flower, because green is the complementary of red.

All these laws give us a general rule which answers the question: "Where do I begin?"

BEGIN BY PAINTING THE LARGEST AREAS

In nearly every case the largest areas will be those which are least specifically defined by the construction and drawing. Examples are the background in a still life, the sky in a landscape, the sea in a seascape, and so on. Your still life may contain a table, a cloth or a rather large object, or the landscape may have hills or fields and bushes or trees which take up a large area. Start with these large areas and try to fill them in as quickly as possible. Paint and eliminate the flat background, especially when it is gray, ochre or red.

HOW?

How do you start to paint a picture in oils? With a lot or little relief? Pale or strong colors? How much detail?

In an attempt to answer these and other questions, in the following section I am going to give a short lesson on the most common oil painting techniques.

LAWS OF COMBINING COLORS

Law of Simultaneous Contrasts—A light color becomes paler in proportion to the darkness of its surrounding color. Similarly, a dark color becomes darker in proportion to the lightness of its surrounding color.

If two colors of different tones are placed side by side, both are strengthened. The light one becomes lighter and the dark one darker.

Law of Maximum Contrasts—Maximum contrast of color is produced by placing two complementaries side by side.

Law of Induction of Complementary Colors—To change any color, you only have to change the color surrounding it.

Chevreul's Law—When a brush stroke of color is placed on a canvas, it not only tints the canvas with the color on the brush but also colors the surrounding area with its complementary.

This may seem strange, but it is true. When your eye sees one color, it avoids overloading the optic nerves sensitive to that color by creating an aura of complementary color around it. If you look intently at a pure green for a moment, you will notice a red halo around it. This may seem like a trick of the eye, but it can be very important when you are choosing tones for your painting.

The Most Common Oil Painting Techniques

Leaving aside palette knife technique for the moment, we can distinguish between techniques which are commonly used by a professional artist. These are *direct painting*, where the painter works on fresh paint, and *painting in stages*, where the picture is completed in several sessions and the artist works on dry or semi-dry paint.

DIRECT PAINTING

We can expand the definition of direct painting by saying that the picture is completed in one or more sessions but the paint must always be fresh, wet or partially wet.

The types of painting where this technique is especially useful include drafts and sketches, rapid sketches and notes, and a large portion of modern and contemporary finished works where the artist has only allowed himself one session to complete his work in an attempt to capture a more forceful and spontaneous effect. From the very beginning, a painting has to be planned with the final effect in mind.

This is one way of starting on a picture. Keep the final effect in mind right from the start and arrange the strength, contrast and harmonization of the colors from the very first brush stroke. With this technique, you cannot have second thoughts or leave the painting even for a moment. Nor can you correct the painting by scraping off the paint with a palette knife as you can with other methods. This would destroy the light touch and spontaneity which characterize this technique.

From the very beginning the artist has to decide simultaneously on the construction, relief and colors.

When you paint over several sessions, you hint at the color of an object, applying it evenly because you know you can come back and give it form by painting in lights and shades. Nor do you bother too much about the shapes because you can correct them at later sessions. You underplay the color with the intention of strengthening it later when the general effect has been elaborated. But the direct tech-

nique does not have these advantages: you must draw, shade, lighten, and give shape and color simultaneously, and irrevocably.

From the very beginning the picture is usually painted with thick paint.

Here is some technical advice for painting this type of picture. Draw with a brush dipped in paint and essence of turpentine, using a dark color, such as gray, bluish gray or sienna, according to the dominant color. Fill in all the dark areas.

Start by painting the large areas with a very thin coat well-diluted with essence of turpentine. This forms a kind of wash which immediately cancels out the white of the canvas and produces an even tone.

Mix the correct color and immediately cover the largest areas which do not require detailed work with thick paint.

Paint the remainder, keeping the colors completely separate. Use clean brushes and a clean palette. Bring out the volume by means of planes and then, immediately afterwards, by mixing and blending adjoining colors.

Put in the last small details with sable brushes and paint diluted with linseed oil or a little turpentine.

This last piece of advice enables you to draw and paint lines, small patches of color, or to paint small shapes on very wet, recently painted areas. You cannot, of course, put in a lot of work on these touches. You should "deposit" the paint rather than apply it by actual brush strokes.

In fact this is really a difficult technique, but it can produce superb results when the artist has full mastery of drawing, relief and colors.

DIRECT PAINTING IN SEVERAL SESSIONS

The same problems arise in the case of direct painting in several sessions but they are less extreme.

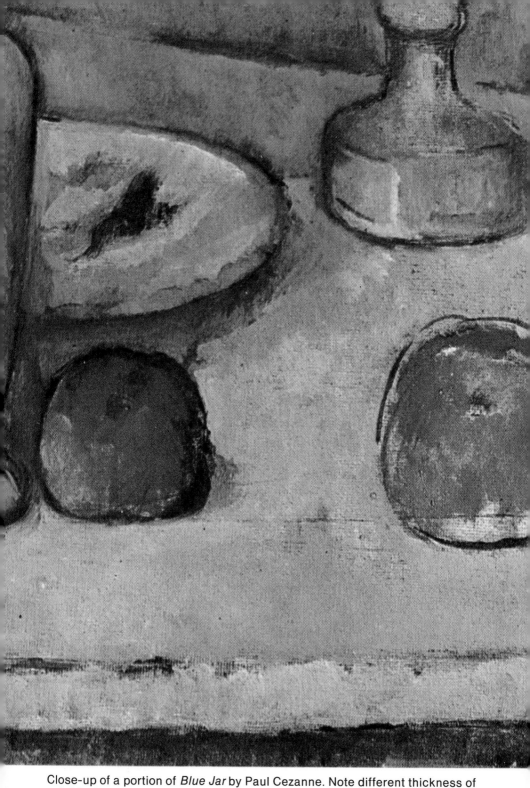

Close-up of a portion of *Blue Jar* by Paul Cezanne. Note different thickness of paint in the oranges and the background.

The picture is begun with one or two thin coats, one at each session, which are mixed from oil paint and plenty of essence of turpentine, but not enough to make the paint run. The first or first two sessions are comparatively short. The sole intention is to give as close an approximation as possible to the final tones. The coats are thin because between sessions, an interval of several hours, the paint can *take*, without being completely dry, so that the tones can be corrected.

You use the direct technique in the last session when you draw, form and paint the final result with heavier layers of paint. These can be as thick as you wish.

As an example of direct painting, probably completed in two sessions, look at the section of Cezanne's *Blue Jar* on the facing page. Note the extremely thin background paint to which has been added a later, thicker coat, in the orange apple on the right and in the yellow-ochre background of the table. If you look at that thin line which outlines and rounds the form of the apple, you will realize that Cezanne painted it with a sable brush and paint diluted with linseed oil. Notice that this direct method has called for such quick and spontaneous work that small areas of the canvas remain uncovered. See how concerned the artist was to enrich his colors, overcoming the monotony of constant colors and tones by speckling them with similar colors. Finally, notice how he encouraged contrasts by emphasizing outlines to make them stand out from their backgrounds.

PAINTING IN STAGES

This is the peaceful, unhurried method used by the old masters and still used today for some large portraits and figure studies. It is based on the idea of splitting up and organizing the work. The artist completes the picture in several sessions, painting on dry or semi-dry paint, drawing and modeling on one occasion, and concentrating on the colors on another.

Right from the start, this technique is completely different from direct painting. When painting in stages, the first concern is to draw and model, putting in light and shade. The colors are a secondary factor for the time being. When the construction has been completed after two or more sessions, the color is applied in several sessions, allowing time for the paint to dry or almost dry. Color is added gradually in accordance with the strength and contrasts required.

The first stage, drawing and modeling, begins with thin coats of almost monochrome gray with slight touches of warm or cold colors depending on the range chosen in advance. The entire picture is drawn and modeled with the help of white, and the values and contrasts are thoroughly explored.

Thicker coats of the real color are then applied on this solid background. The early thin coats are painted with essence of turpentine as the solvent and no linseed oil. The top coats are painted with oil paints as they come from the tube or diluted with more linseed oil than essence of turpentine.

The absorptive powers of the early coats assist in drying the top coats, allowing the artist to paint and repaint to produce dragged brush work and rubbed work.

When they came to paint the top coats, the real painting as opposed to the preliminary coats, some old masters used the direct painting method in several sessions, which produced a freer and more spontaneous style.

THICK ON THIN

Although each technique employs different methods, direct painting and painting in stages have one feature in common: The first coat must always be thin and diluted with essence of turpentine.

This brings us to one last theoretical point before we finally return to our practical exercises: paint must be applied *thick on thin.*

Thin Paint contains little or no oil. Tempera or gouache are examples. Mixing essence of turpentine with oil paint dilutes and reduces the amount of oil in the paint and makes it thinner.

Thick Paint contains normal or large amounts of oil. Oil paint direct from the tube contains what is considered the normal amount of oil. Mixing or dissolving linseed oil in oil paints increases the amount of oil in the paint and makes it thicker.

The rule of *thick on thin* means that good oil painting requires a thin first coat over which the later coats of thick paint are applied.

The old masters carried this to such an extreme that they painted the first coat with egg tempera. Then they painted with oils over this base coat. Today, tempera or gouache can be used for the same purpose, but few, if any, contemporary artists apply oil paints onto a thin background of tempera or gouache. As far as we are concerned, the following method works very well.

For your first coat, mix more essence of turpentine into your oil paints than you use for later coats.

All right, you say, but why all this thick and thin business in the first place?

There are two important reasons. First and foremost, if you paint thick on thin, you can be certain that your picture will last longer and not suffer any real disasters when drying.

We have already seen that oil paints diluted with essence of turpentine are more liquid and thinner. We also know that essence of turpentine evaporates very quickly. Therefore, thin paint dries rapidly and efficiently.

On the other hand, thick paint containing oil dries slowly and, what is worse, misleadingly. If you apply oil paint to a canvas just as it comes from the tube and let it dry, within four or five days a kind of skin will form over it. This will appear to be dry but, in fact, the paint beneath will still be wet and pasty. As it dries, this paint *will contract and shrink the outer layer.* After two or three weeks, when the paint is

Detail from *Woman With Fan* by Velazquez showing the pattern of cracked paint.

really dry, the paint will look like an empty skin. If this thick oily paint had been applied on a thin base, the empty skin effect would have been the only result, but imagine that four or five days after painting this thick layer, you applied a coat of thin paint over it. You can guess what would happen. The thin coat would dry quickly, forming a hard, compact but thin crust. This crust would be so thin that it would be unable to resist the shrinking and distortion of the paint beneath it. It would eventually split, giving the characteristic appearance of cracked paintings. The detail of Velazquez's *Woman with Fan* on page 117 clearly shows how the paint has cracked.

The second reason for the thick on thin rule can best be explained by the fact that if the first coat is thin, it dries rapidly. In your next session you can paint on a dry or half-dry surface. This allows you to touch up and repaint without the previous colors affecting your work.

There are a few things left which you need to know about oil painting. The canvas with the still life of Beethoven's head and the roses is still waiting, drawn, constructed and ready for painting. So, let us study these few things while we are painting.

FIRST STAGE

MATERIALS

Titanium white	2 Flat No. 4 hog brushes
Medium cadmium yellow	Flat No. 8 hog brush
Yellow ochre	Flat No. 12 hog brush
Burnt umber	Sable No. 2 brush
Cadmium red	Palette
Alizarin crimson	Essence of turpentine
Viridian	Oil jars or a small container
Dark cobalt blue	Thick Canson paper
Ultramarine blue	Rags, pushpins

I begin with my flat No. 12 brush, working on the background, applying a thin coat, so thin that the grain of the canvas can be seen in the illustration of this first stage on the facing page. For this color I use plenty of white mixed with yellow ochre, burnt umber and ultramarine blue diluted with essence of turpentine. I increase the amount of ultramarine blue when I reach the lower right section. On the left I add more umber and a touch of red.

I now paint the shadow cast by Beethoven's mask using the same color as the background plus cobalt blue, umber and a little alizarin crimson.

I go on to the mask itself. I change the previous color by adding white and ultramarine blue. I apply a few lighter touches with a very little ochre and much more white, painting the reflected light.

I now paint the table with ochre, umber, red, a touch of alizarin crimson, a little viridian and a touch of white using my flat No. 8 brush. Then I adjust the color by adding a little of the background color which contains white and is dirty.

DIRTY COLORS

Titian is said to have recommended using *dirty colors*, meaning that one should never paint with strident, discordant colors. Indeed, nature contains almost no absolute colors such as pure red or pure yellow. We only paint with such colors to produce a specific effect. But, when we want to copy nature, we must follow Titian's advice and add blue. Blue is the color of shadows, space and atmosphere.

I paint the jar using the flat No. 8 brush again with the color it already carries plus umber, red, and alizarin crimson.

Now to the sheet of music. With the flat No. 12 brush which still carries the warm gray of Beethoven's mask, I paint the darkest strip along the center of the rolled-up sheet. Just an ordinary strip of color. Then I clean the brush with my rag and take up some white and yellow. I mix this together and almost automatically obtain the yellowish gray of the reflected light. I paint and blend, shading (after wiping the paint off the brush with my rag) the dark gray of the first strip into the yellowish gray of the reflected light. Finally, with a flat No. 4 brush and clean white, I paint and shade the upper illuminated section.

I move on to the rose, using the two flat No. 4 brushes. Please take note of these colors. I mix a clean white and clean red for the light roses and a white with a touch of alizarin crimson and cobalt blue for the shadowed section of the petal which seems to be rolled up.

Yellow and ochre mixed with red give me the orange reflections that are lightened by mixing in the first rose color, which also improves harmonization.

I mix alizarin crimson, umber and red. Here and there I add a touch of Prussian blue and, where suitable, lighten it with the rose color of the highlights to produce harmonized color.

Finally the leaves. For those on the upper half of the bud's stem, I use viridian and burnt umber with some alizarin crimson and ultramarine blue where I think it advisable. The ultramarine makes the mixture grayer. The dominant color will, of course, be provided by the viridian. For the other leaves, I use the same color, but lighten it with ochre and red. No white! If necessary, I can add yellow.

SECOND STAGE

Now, let's see whether we are on the right track with this first stage.

I didn't say anything before, but for a short time this morning, the sun went behind a cloud, and the studio here was tinged with a blue light. Not much, but it lost some of that warm golden atmosphere which had prevailed until then. This made feel me that a bluish-green background would provide a better contrast than the creamy background of the first stage.

There is no question about it now. Why didn't I realize it before? The flowers are rose-colored, but the tonal colors, the shadow, have an orange, vermilion and even red tint. The complementary of red is green. A background of strong green would provide the maximum contrast with the red but it would have an unpleasant effect because of the similarity of tone. However, a light green background with a slight tinge of blue would produce perfect harmony of color within an equally strong contrast of color.

That is how it is, at least in theory. There is a rule about this which is worth remembering: *Two complementaries whose tones are dissimilar produce excellent harmonization.*

I repaint the background using the same color as before, but after adding viridian, ultramarine blue and a very little burnt umber.

No, that won't work. I must clean my brush with the rag and make a new mixture which contains a little yellow and ochre as well as the previous colors.

That's it. It's not as clean a background color as I wanted, but it will have to do for the time being.

Of course, I must readjust the tone of the shadow cast on the wall and the shadow of Beethoven's mask. I use the same range of color by adding ultramarine blue and a little alizarin crimson in the shadow. On the mask I apply the new background color with white and ultramarine blue.

The table, sheet of music and jar now contain slightly more green and burnt umber as shown in the illustration opposite.

I have spent over a quarter of an hour on the rose and still can't get it right. It is probably best to rub out what I have done and start over.

STARTING AGAIN FROM SCRATCH

I had to do it, there was no other way! It is always annoying when you have to go back and start over.

You must do the same when you have to. You will always gain by it. And see how easy it is.

Make a round bundle of clean rag and rub it gently over the painted area.

Change the rag for a new piece and rub again. The advantage of this method is that a trace of the previous color is always left, a dirty grayish trace which you can easily paint over.

You can also remove paint with a palette knife by scraping it flat across the canvas. This is necessary when the paint has been applied in a thick coat. After the palette knife has removed most of the paint, use a rag for cleaning off the rest.

It was worth the trouble. This time I got the rose just the way I wanted, much more detail and color than before. I should have mentioned that before painting it, I outlined it with a thick line of umber and Prussian blue—almost black—well diluted with essence of turpentine. I did the same in the first stage.

Of course, when I was painting and repainting the background, I spoiled some of the leaves by spreading the background color over

them. It doesn't matter. I can paint them again and make them larger. Notice this detail in the painting on the page 122. Again, I outline their shape by spreading some of the background color onto them. Let's take a break and come back to the painting tomorrow.

THIRD STAGE

Good morning. These hours of rest have been put to good use. When a picture is left for a while, you have time to think about it, to forget it a little. When you come back to it you can see new aspects, shades and colors in the model. You can also notice your own faults and correct them. In our picture, the paint has dried enough for us to be able to complete the work in one session of direct painting.

The paint is thick enough to cover the grain of the canvas.

Once more I start with the background. A few tests, a few uncertainties and I've got it: viridian green, yellow, ochre, umber and ultramarine blue, with white, of course. In the upper right section I emphasize the yellowish tendency. Below it and on the left, I use more ultramarine blue and viridian.

I go back to the mask. As before, I use the background color with burnt umber and ultramarine blue for the shadows. In the middle of the illuminated section of the head, I apply white which has been slightly tinted with the background color and ultramarine blue. This ultramarine blue and clean white is ideal for showing highlights. Remember, clean brush, clean palette, clean colors. I have added some Prussian blue in the shadow to make it more luminous and transparent.

I am concerned with the construction of the head. Luckily oils are the ideal medium for changing and correcting forms.

I lighten the shadow on the sheet of music. I paint the staves, notes and signs, not precisely but, as you can see, vaguely and solely as a form of indication, although each is correctly placed and colored. They are lighter in the illuminated section than in the shadowed area. I use a greenish gray with umber.

I go back to the head, painting with the tip of my little finger. I move the line of shadow by the nose slightly. I correct the position of

the wrinkle at the edge of the nostril. I paint and correct with my finger merely by picking up light paint and scraping it to cover and move the dark shape. It is very easy: try it.

PAINTING WITH YOUR FINGERS

The first mention of this trick is made by Leonardo da Vinci and Titian, but all Renaissance painters probably used it. Indeed, Titian painted not only with all his fingers but also with the edge of his hand. I have done this myself with very good results.

Needless to say, you do not pick up paint with your fingers and apply it to the picture as you do with a brush. You use the fingers to work over sections which have already been painted.

This technique is only useful to obtain specific effects. It is particularly useful for fine blending or shading and also for making slight alterations to points where the light and shade meet. It is used primarily in portraits or subjects in which the drawing, forms and colors must be very accurate. In the mask of Beethoven, for example, I used my fingers on many occasions for forming, shading and blending. It is so easy! Much easier than using a brush because the control is more effective and closer, and the pressure is more sensitive and accurate.

Moreover, the fingers smooth the paint so that it is easier to paint a detail in light color over an area which has been treated with the fingers. I have done this when painting the edges of the rose petals. First, using a flat No. 4 brush, I speckled the dark colors, the shaded areas of the rose and alizarin crimson parts, keeping the model in view. Then I worked over the same areas with the tip of my third and little fingers, blending, shading and smoothing. Finally, I painted over these areas with a sable brush loaded with undiluted white, red and alizarin crimson paint straight from the tube.

USING A MAHLSTICK

Now I add some small touches with my sable brush and the mahlstick I mentioned on page 39. Mahlsticks have been used since the Renaissance to support an artist's hand and arm while he applies those delicate finishing touches that perfect a painting. A mahlstick is a straight rod with a knob at one end for resting your arm. The control you can get is wonderful. Look how I finished the features of the mask and the interior of the rose.

Now you can go on by yourself. One last piece of advice:

LEARN TO STOP

There is nothing more difficult than to stop in time, to cease painting before the work becomes fussy, precious and expressionless. An unpolished, sketchy finish is a thousand times better.

Gauguin said in this connection: "Do not put too much finish on your work. A good impression only lasts when the initial freshness survives a lengthy search for tiny details."

Now sign it. Not too big and in a quiet color. Then, after a few days, you can varnish the painting, if you want.

VARNISHING A PICTURE

You should varnish a picture to protect the paint from dirt and dust. Varnishing will also increase the brilliance and strength of the colors which have remained matte because of their composition or because they were diluted with too much essence of turpentine. Varnishing will also give equal strength and brilliance to all colors in a picture.

Many modern artists do not use varnish because they prefer a matte finish. This is obtained by using less linseed oil as a solvent and by using an absorbent support such as cardboard or wood with matte priming.

The main drawback of varnish is, in fact, its primary quality: its shine. Under certain conditions, this can prevent a proper view of the picture.

Varnish for painting is sold in bottles ready for use. Before applying it, the picture must be absolutely dry. This may take a month or so. Oil paints dry very slowly, especially if the paint is thick. Varnish is applied with a broad flat brush which should be made of sable, but hog brushes can be used.

So now you're finished. I hope you're pleased. I'm always surprised how good it feels to finish a painting, yet how tiring it can be. Take a rest. Start again tomorrow. Your next painting will be even better.

D - 5 . 8 2 9 6 1 4 1 2 2 9 2 9 0 - 1 0 0